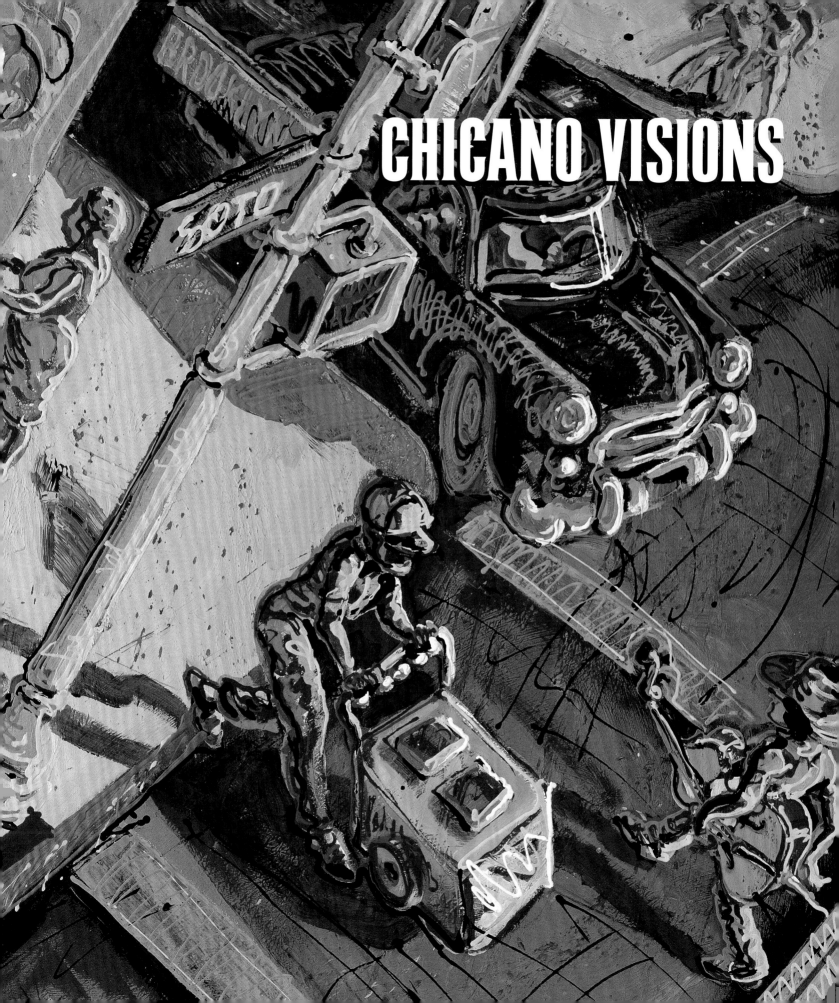

CHICANO VISIONS

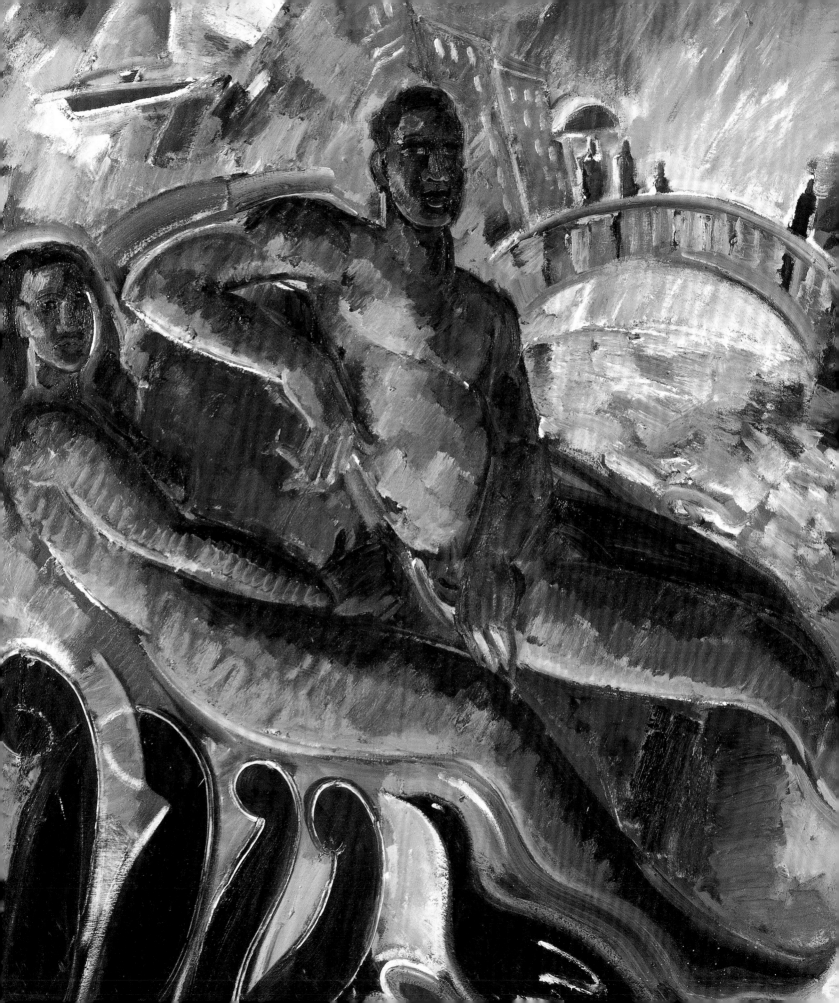

CHICANO VISIONS
AMERICAN PAINTERS ON THE VERGE

CHEECH MARIN

ESSAYS BY MAX BENAVIDEZ, CONSTANCE CORTEZ, TERE ROMO

A BULFINCH PRESS BOOK
LITTLE, BROWN AND COMPANY
BOSTON NEW YORK LONDON

First published on the occasion of the exhibition "Chicano Visions: American Painters on the Verge"

Page 1: Wayne Alaniz Healy. *Beautiful Downtown Boyle Heights,* detail
Pages 2–3: Carlos Almaraz. *California Natives,* detail
Page 5: Rupert García. *Homenaje A Tania y The Soviet Defeat,* detail

First North American Edition

ISBN 0-8212-2805-6 (hardcover edition)
ISBN 0-8212-2806-4 (paperback edition)

Library of Congress Control Number 2002104645

A Bespoke Book
Design: Ana Rogers

Bulfinch Press is an imprint and trademark of Little, Brown and Company (Inc.)

Printed in Singapore

CONTENTS

INTRODUCTION

THE CHICANO SCHOOL OF PAINTING

The first time I stood in front of a Chicano paint-
ing—it was George Yepes's *Amor amatizado*—
I had the same feeling as when I first heard a
tune by the Beatles. It was a sense of experi-
encing something very familiar and very *new*.
The Beatles had built their music on the backs
of their rock 'n roll heroes, but their interpreta-
tion was fresh and distinctive. As the Beatles
started writing their own songs, their own roots
were clearly evident, and yet they were moving
beyond the influences around them to create
a whole new musical landscape. The same
can be said about my appreciation of Chicano
painters: The more art I looked at and thought
about, the more that initial feeling of something
new and "known" was reinforced, and with it
a recognition of something powerful at work.

Having been self-educated in art from an
early age (I was probably in the fifth or sixth
grade), I recognized the various models from
which the Chicano artists drew inspiration:
Impressionism, Expressionism, the Mexican
Mural Movement, Photorealism, *Retablo* paint-
ing, are all examples. But the common link of
course was the central "influence" common to
all the artists—they were Chicanos and looked
at the world through Chicano eyes. Over time,
this so-called common link begat something
broader and more important. A much larger
picture was emerging, and that picture was a
new school of art in formation.

Gronk. *La Tormenta Returns.* 1999 (detail)

If a school can be defined as a place where people can come to learn, exchange ideas, have multiple views and different approaches to the same subject, and influence each other as they agree and disagree, then a Chicano School of Painting more than qualifies for such a definition. What distinguishes this body of work is of course not simply that it has no interest in rehashing the familiar landmarks of Impressionism, say, or abstraction or pattern & decoration. Nor is this art whose mandate is a reaction against other stylistic precedents in the history of art. Rather, it is a visual interpretation of a shared culture that unfolds in one distinctive painting after another.

The art movement developed outside of the national or international spotlight, and in separate locations, notably Los Angeles and San Antonio. In its earliest days, three decades ago, this was a movement that developed organically, with little communication among the artists. What bound them together was the DNA of common shared experience. Yes, there were a few important groups (Con Safo, Royal Chicano Air Force, Los Four, and Asco), but in general many of the artists shown in these pages never even met before their work was collected in the exhibition "Chicano Visions: American Painters on the Verge." With little commercial encouragement, these artists have struggled to gain acceptance in the gallery world. Many painters show their works in restaurants, coffeehouses, or wherever there is a wall and an audience. What matters is that they continue to create.

Overwhelmingly university or art-school trained, these artists were exposed to art history and major contemporary world art trends in addition to the constant and surrounding influence of Mexican art and culture. Indeed, it is this blending of influences—traditional Mexican and American Pop— that defines the school. Simultaneously naïve and sophisticated, the art mirrors the artists' own experience of a bicultural environment. Chicanos "code switch" amongst themselves all the time: they go back and forth almost at random between languages and cultures both spoken and visual. Code switching allows for total immersion, the creation of a whole greater than the sum of its parts.

Going into its fourth generation of artists, the school continues to grow without losing its essential characteristic—the visual interpretation of the Chicano experience. Whatever the means—historical, political, spiritual, emotional, humorous—these painters each find a unique way to express their singular point of view. And just as Chicanos have been influenced by their predecessors, so now they exert an influence on American pop culture. From hip-hop dress to the predominance of salsa as the number one condiment—over ketchup!—the Latin experience is not just recognized as something "interesting," a "colorful sidelight," but as one of the main threads that makes up America's cultural fabric.

In the end, however, it is the lone art lover standing in front of a great painting with his jaw dropped, transported to a place both timeless and immediate, that provides the ultimate validation for this new movement in art. For more than twenty years, Chicano painters have done that for me. I pass along this world with love and affection, *y con amor, carino y besos.*

—Cheech Marin
San Francisco, 2002

Frank Romero. *The Arrest of the Paleteros.* **1996 (detail)**

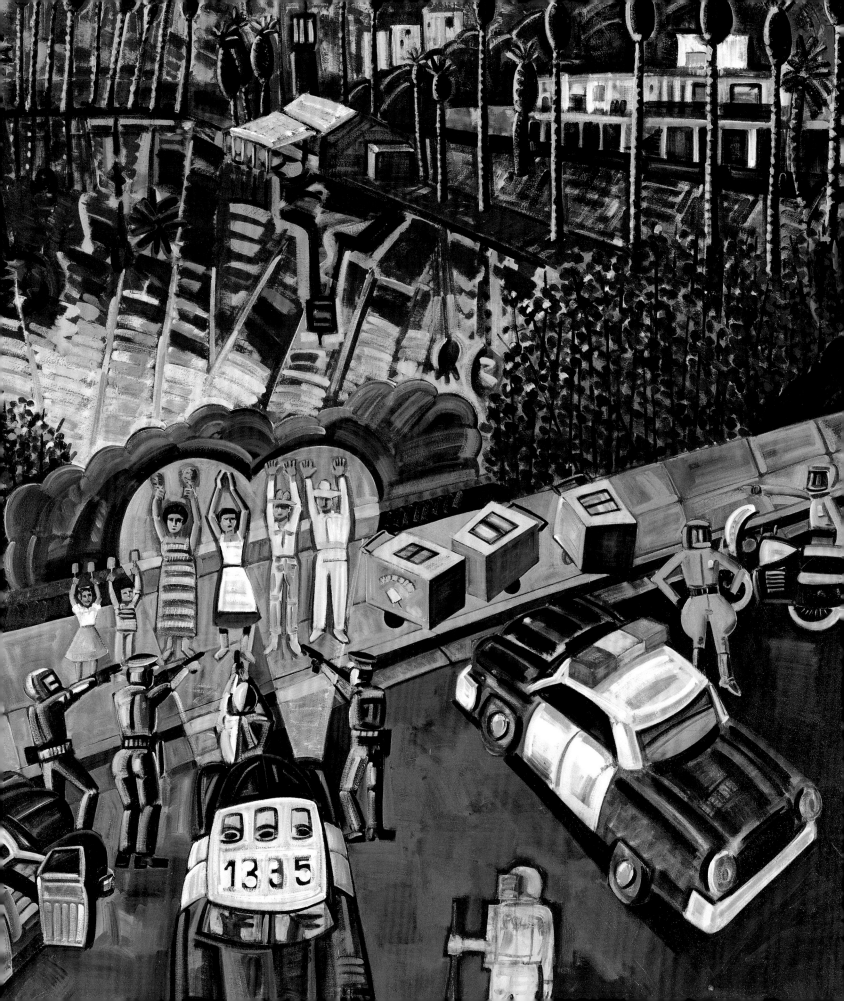

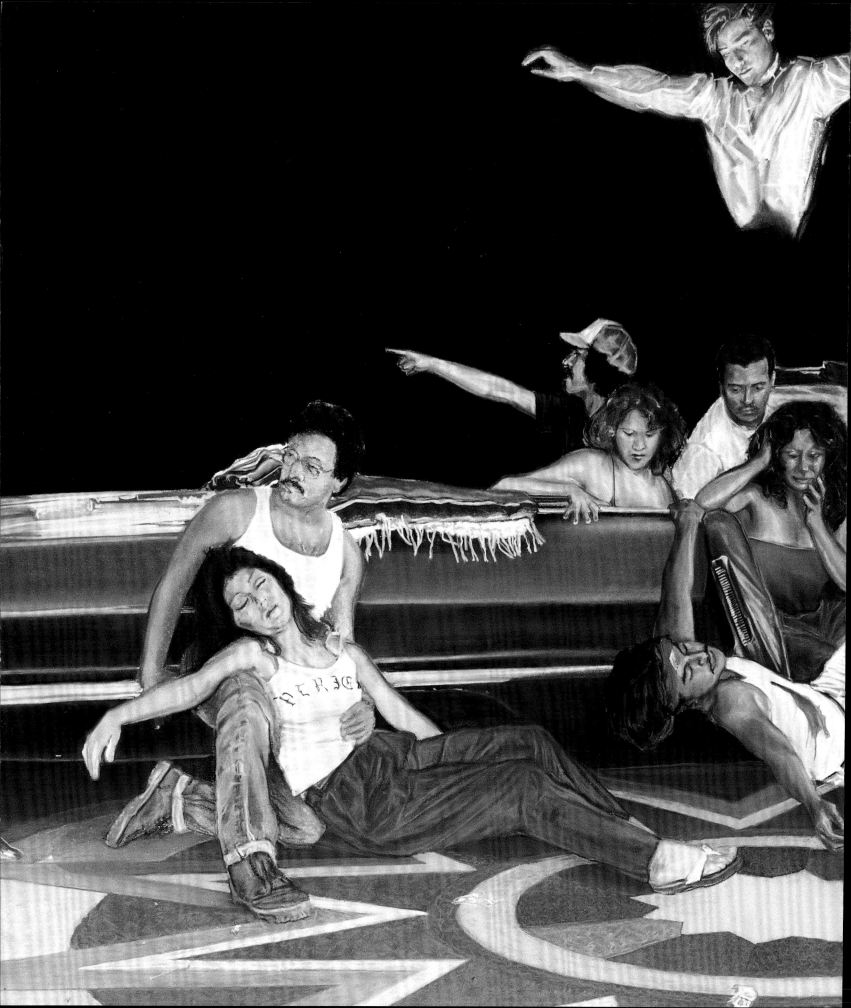

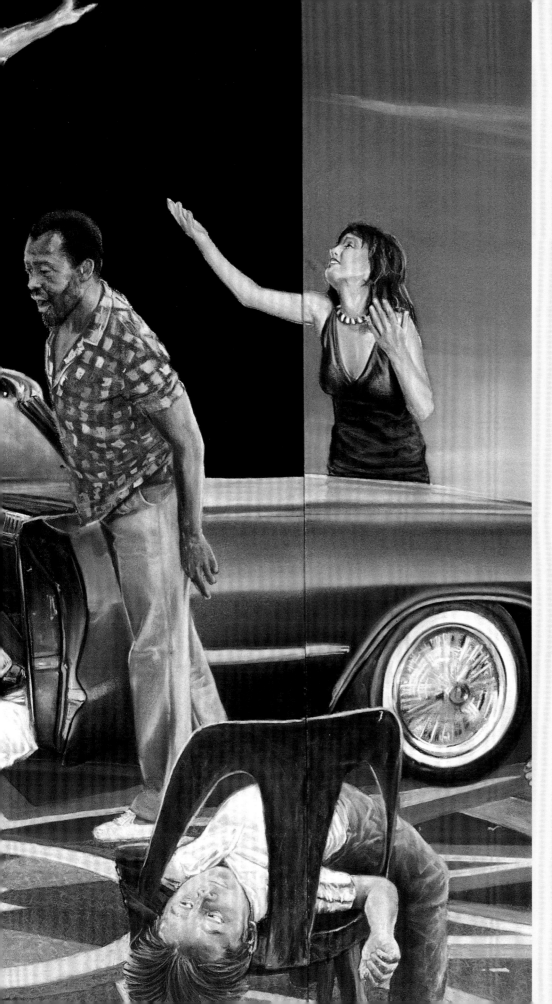

CHICANO ART:
Culture, Myth, and Sensibility

By Max Benavidez

It was late at night in City Terrace, a barrio in East Los Angeles, 1972. Willie Herron, a young Chicano artist, was walking home alone when he heard groans coming from a nearby alley. He made his way down the dark, gravelly pathway of debris and broken glass and saw his brother lying in a pool of blood.

As Herron tells it, "He had been stabbed maybe twelve times . . . tissue, blood, and stuff was coming out of him." Seeing his brother so badly hurt by gang violence filled Herron with a rush of ambivalent feelings. The next morning he walked into the bakery whose backside faced the very alley where he had found his wounded sibling and asked if he could paint a mural on the wall.

By the end of a feverish day, he had produced a stylized rendering of muscular arms bursting up through a cement street. Integrating the texture of the rough, concrete wall with angry gang graffiti into his work, Herron had distilled a situation he knew all too well, and created what would become the most famous Chicano mural in the world, *The Wall That Cracked Open*. By metaphorically breaking open the wall, the artist took the Chicano art of his time beyond illustrative poster design and into the symbolic realm.

The mural became a tour de force of Chicano art by depicting familiar Chicano imagery—the praying *madre* (mother) with her

John Valadez. *Getting Them Out of the Car*. 1984 (detail)

crucifix, a *calavera* (skull) symbolizing death, conjoined with a Mexican wrestler's mask—near an emotionally infused site. To this day the wall work is a testament to the social, economic, political, and psychic violence prevalent in the poor barrios of Los Angeles.

Herron's mural marked a new phase in the growth of the Chicano community's artistic expression—its presence signaled the birth of fresh themes and styles. Earlier influences, such as Mexican muralism and European and New York art trends, were subsumed by the socio-economic realities at hand. Something provocative and unique to Chicano art was born that day in the East Los Angeles alley.

The Roots of a Migrant Consciousness

The term *Chicano* means the politicized Mexican-Americans who have resided in what is today the Southwestern United States since the earliest days of Spanish exploration in this region, the early 1600s. To Chicanos, the area from California on the Pacific Coast in the west to Texas in the east and as far north as Colorado is known as Aztlán, the mythical homeland of the Aztecs.

According to the myth, the Aztecs or Mexica (*Mee-sheeca*) were originally from an island, "the place of the white heron" (Aztlán), that was located in a far-off lake, which some say is the Great Salt Lake in Utah. The nomadic Aztecs are said to have migrated from Aztlán and arrived in the Valley of Mexico around 1250. By 1345 or so, they began building their capital, Tenochtitlan (place of the cactus fruit), modern-day Mexico City. Their worldview was built on a synthesis of previous cultures such as the Toltecs, known as the great artificers of ancient Mesoamerica, and others. As the historian Hugh Thomas discovered, they also built their society "on a myth of eventual cataclysm."

By November 1519, when Hernando Cortés with his expeditionary force of six hundred *conquistadores* and an army of Indian allies arrived in Tenochtitlan, the Aztec empire was a far-flung confederation. Built on overwhelming military might and a flourishing economic trade, the empire, based in Central Mexico, dominated millions of people and all the land from the Pacific Ocean to the Gulf of Mexico and as far south as Guatemala.

The Spaniards were astonished by the capital city they found, comparing its population (a quarter of a million people), its material riches, political structure, religious ceremonies, architectural splendor, and giant pyramids to Venice, Constantinople, and Rome. As the cultural commentator J. Jorge Klor de Alva has observed, the encounter between the Aztecs and the Spaniards was "perhaps the most consequential meeting of cultures ever." Two great civilizations confronted each other and out of that confrontation would emerge, in the course of the next four hundred and fifty years, today's Chicanos.

According to Miguel Leon-Portilla, chronicler of ancient Mexico, the culture clash between the Aztecs and the Spaniards represented "the meeting of two radically dissimilar cultures, two radically different modes of interpreting existence." Between the portentous day in 1519 when Emperor Montezuma II and the explorer Cortés met in Tenochtitlan, and August 1521 when the Aztecs surrendered to the Spanish after a brutal 108-day siege, a definite pattern of cultural engagement was set in motion.

While the Aztecs may have seen the Spaniards as returning gods, the Europeans viewed the native Mexicans as barbaric, non-Christian, less than human. After all, the Spanish knew how to treat those they called pagans. As recently as 1492, Spain had issued a decree expelling all Jews from Castile unless they converted to Christianity. That same year they had driven the Islamic Moors out of Grenada. Today we would call the *conquistadores* militant, fundamentalist Christians. In their fanatic drive to make the

world safe for their Christian God, the Spanish propagated a worldview that correlated Christianity and whiteness with superiority and civilization, and set in motion a virulent racial dynamic that has infused human relations in the hemisphere ever since.

The violence and terror that marked this encounter produced a new race, the *mestizo*, or mixed blood, arising out of the sexual union between Spanish men and Indian women. Over the centuries, this ongoing process of protean synthesis and struggle for identity is now referred to as *mestizaje*. It could even be said that the legend behind the Virgin de Guadalupe, Mexico's patron saint, has elements of this type of syncretism.

Spanish colonial domination, which lasted for three centuries, was typified by racial and economic disparities. After Mexican Independence in the early nineteenth century, the next major event in the development of Chicano consciousness was the Mexican-American War of 1848, the defeat of the homegrown Spanish-speaking population by an English-speaking armed force.

By the early twentieth century, the earliest of numerous succeeding waves of Mexican immigrants had begun, starting out with refugees and exiles from the Mexican Revolution. During this period, clear patterns of behavior emerged that helped set a mold or a frame around defining Chicano characteristics. These features included extreme hybridity, a sense of existential anxiety, the fusion of the primitive and the modern into a new vision, and a general need to prove oneself as equal to the dominant group. The Chicano is a synthesizer par excellence by heritage and ancestry. Ultimately, it can be stated that the Chicano represents the migrant consciousness, a territory between the familiar and the strange, between languages, between cultures.

This historical background shows that notions of radically dissimilar cultures, of a struggle for identity, and of the need to synthesize and combine juxtaposed modes of being all have a centuries-long tradition for Chicanos. It also clarifies the interaction between Chicanos and the dominant culture in the United States, which today is represented by the Anglo-American model of a Western European-oriented, consumerist, and media-driven society. To take from one's own culture, add elements from the American and European mainstream and avant-garde, and create something new is the hallmark of modern Chicano art.

The Precursors

History's stamp is the first chapter in this story. Next comes Chicano art's aesthetic antecedents—those forces and visionaries that set down the basic parameters of the imagery, style, and content that influenced artists, particularly those from Los Angeles. The most influential were Los Tres Grandes (the three great ones) of Mexican muralism: Diego Rivera, David Alfaro Siqueiros, and José Clemente Orozco; the hyper-selfconscious portraitist Frida Kahlo; the assertively nonconformist *pachuco* street style of the early 1940s; and the visual bravura of L.A.'s ubiquitous Mexican-American gang graffiti. Lastly, there is the "city of quartz" itself, the great churning, freeway-sliced megalopolis of Los Angeles, a city founded in 1781 by a multiracial band of Mexican settlers, and often viewed as the prototypical twenty-first century model of urban sprawl and estrangement. Stir it all up and we have true art noir, Chicano style.

Many people are unaware that the greatest Mexican poet of the twentieth century, Xavier Villaurrutia, spent time in Los Angeles during the 1930s. As an openly gay writer, Villaurrutia moved to Los Angeles to escape the homophobia of Catholic Mexico. While there, he wrote his magnum opus,

Nostalgia for Death. In the book's signature poem, "L.A. Nocturne: The Angels," Villaurrutia wrote:

Si cada uno dijera en un momento dado,
En solo una palabra, lo que piensa,
Las cinco letras del DESEO formarían una enorme cicatriz luminosa,
Una constelacíon más Antigua, más viva aún que las otras.

If, at a given moment, everyone would say
With one word what he is thinking,
The six letters of DESIRE would form an enormous luminous scar,
A constellation more ancient, more dazzling than any other.

It is this yearning that holds together the personal and the political. The writer and social observer Bell Hooks tells us that, "Surely our desire for radical social change is intimately linked with the desire to experience pleasure, erotic fulfillment, and a host of other passions. . . . The sacred space of 'yearning' opens up the possibility of common ground where all these differences might meet and engage one another." For many Mexicans of Los Angeles, the 1930s were a time of intense desire for personal fulfillment and radical social change. Consider the global landscape: There was worldwide economic depression, Fascism and anti-Semitism were on the rise in Europe, and during this decade, U.S. citizens of Mexican origin were being deported to Mexico (on a one-way, government-issued train ticket) by the tens of thousands. Under those conditions, DESIRE (in every sense of that potent word) could well have been emblazoned like a giant scar in the sky above L.A.

It was into this world that in 1932, David Alfaro Siqueiros, at the time one of the world's most famous artists and a member of the Mexican Communist party, arrived in Los Angeles, in temporary exile from the travails of post-revolutionary Mexico. Contracted to teach a mural class at the Chouinard School of Art (now the California Institute of the Arts), Siqueiros's visit actually immersed him in a series of controversies that prefigured much of L.A.'s Chicano art.

While in Los Angeles, Siqueiros painted two murals that caused immediate controversy. The first, *Mitin en la Calle* (Meeting in the Street), was a fairly straightforward rendering of black and white people listening to a union organizer. Siqueiros's figures stand comfortably close together in a way that belies the racial tensions of L.A. in the 1930s. Perhaps for this reason, local response to the work was quick in coming: City residents were so outraged by the piece that it was destroyed.

The second and even more controversial Siqueiros mural was commissioned by a gallery owner who insisted on the right to pre-select the mural's theme in the aftermath of *Mitin en la Calle*'s harsh reception by the watchdogs of local culture. The last thing he wanted was the negative response that had greeted the first mural.

As the patron saw it, *America Tropical* would be a lush and placid expression of Latin America's pastoral beauty. Siqueiros, however, interpreted the theme in an entirely different way, and dedicated the mural to the Mexican working class of Los Angeles. The completed mural measured eighteen by eighty-two feet, and was painted on a second-story outer wall above the old plaza of Olvera Street. With his typical sweep of energy and motion, Siqueiros depicted a barefooted Mexican Indian strapped to a wooden cross with the rapacious talons of an American bald eagle perched above his head. Symbolically, the bound peasant—representing the city's growing brown underclass—was easy prey for the

economic appetites of the U.S. ruling classes. The plaintive and unmistakable intent of *America Tropical* again caused a backlash: The mural was whitewashed by the city, and soon afterward Siqueiros was expelled from the United States.

Although efforts are now underway to restore *America Tropical,* Siqueiros's experience set a pattern for Chicano public artistic expression in Los Angeles: Art and political comment should not be mixed in public works made by a Mexican, no matter how talented or famous. Siqueiros understood that Mexicans in Los Angeles were being treated badly, and that race, class, and exploitation insinuated themselves into the daily lives of brown-skinned, Spanish-speaking workers.

American Tropical helped frame other forms of public expression, especially gang graffiti. Although the literature is too thin to document its initial development, some observers from the time suggest that the first graffiti insignias were visible in Los Angeles as early as the 1930s, when summer heat liquefied the soft black asphalt on the streets and Mexican youth scooped it onto ice cream sticks to sign their "tag" on Eastside walls. As a form of guerrilla art, graffiti's style proclaims the presence of the angry and the unseen. Graffiti, in a sense not unlike Siqueiros and his in-your-face dismissal of a preselected theme, combines blatant defacement and disdain for the mainstream, a rejection of property rights and imposed boundaries. It is a secret code of communication by outcasts. It could even be argued that graffiti functions like conceptual and Pop art in the way that it questions the context in which art is appreciated.

Gronk, a contemporary artist who first gained attention for his mural work, has said that, "I didn't go to galleries or museums. They weren't part of my childhood. But all I had to do was walk outside my front door to see visual images all around me. Graffiti was everywhere and it helped develop a sense for what I wanted to do." Given these two visual precedents—the censored *America Tropical* and the encoded language of urban graffiti—it's no wonder that L.A.'s Chicano artists have produced politically tinged wall works as powerfully dramatic as Herron's *The Wall That Cracked Open* and as instructive as Judy Baca's *Great Wall,* with its scrupulously researched alternative history of Southern California.

Another major influence on Chicano art was the *pachuco,* the 1940s-era version of today's low-rider and a distant cousin of contemporary street gangs. Nonviolent and primarily a swaggering statement of bold style, the zoot suiter with his exaggerated clothing and long hair shaped into a pompadour served as the visual embodiment of a subculture replete with its own unique language, dress, and code of speaking. Memorialized in Luis Valdez's play, *Zoot Suit,* the *pachuco* is a symbol of the utter disregard some Mexicans felt toward mainstream cultural values. With his sartorial excesses and almost ritualized deviance, the *pachuco* allowed neither condescension nor dismissal.

For their part, most Anglos of the period who were living in the desert city of Los Angeles, had little or no frame of reference for the *pachuco*'s deviant mannerisms. Nor did the mainstream culture understand or accept the narrow set of social expression expected of Mexicans. So it was that in the early 1940s, during the war, *pachucos* rubbed against the grain of a society already on edge and by their presence disrupted society's myth of consensus. Although considered by many people in their own community to be emblems of cultural pride, the arbiters of Anglo mainstream thought the *pachucos* were ultimately out of control.

In 1943, a heat wave of media stories about juvenile crime in East Los Angeles led to a massive response by the city: U.S. soldiers stationed in the area went out into the streets and, acting like a mob, beat *pachucos* with bats, shaved their heads, stripped them naked, and left them bloodied and humiliated in full public view. The message was clear: Challenge our way of being and you will pay the price. As

noted by *Time* magazine in its June 21, 1943, issue, mob violence had become the modus operandi of law enforcement, not the citizens:

> The police practice was to accompany the caravans (of soldiers and sailors) in police cars, watch the beatings and arrest the victims. The press, with the exception of the *Daily News* and the *Hollywood Citizen News*, helped whip up the mob spirit. And Los Angeles, apparently unaware that it was spawning the ugliest brand of mob action since the coolie riots of the 1870s, gave its tacit approval.

Just as Siqueiros's work was erased from public view because it exposed American racism, the defiant *pachuco* was handled with frontier justice. The beatings, arrests, and accompanying alarmist news stories filled with stereotypical portrayals of Mexicans validated the dominant culture's ideology. Mexican insurgence, even if just a set of cocky mannerisms, style, and linguistic usage, was to be condemned. Punishment was doled out by marauding American soldiers.

During the late 1930s and throughout the 1940s, Frida Kahlo, an artist living in an outlying district of Mexico City called Coyoacán, came to prominence. Not only did Kahlo wake up the world to a new style of Mexican art, she directly influenced Chicana artists in the United States. Social rules meant little to this woman whose passions dominated her life. Being Mexican was both a devoted life mission and an art form, and she often dressed in the beautiful native costumes of the fiercely independent women of Tehuanatepec. To Kahlo, the United States was simply *gringolandia*, a place of crass materialism to be avoided at all costs.

Her work incorporated the Mexican folk art of *retablos,* small, votive paintings often made on tin as offerings to the Virgin Mary as a form of thanks for a miracle of some sort. Classic Mexican indigenous imagery also appears, such as *My Birth* (1932), in which the artist echoes an Aztec statue, circa 1500, that depicts the goddess Tlazolteotl in the act of giving birth. Kahlo's uniquely Mexican worldview, her perseverance in the face of nearly impossible odds, and her stunningly original self-portraits, piercing and almost painful to look at, are her lasting influences on Chicano art. She is the quintessential model of the union of life, art, and culture in the face of extreme adversity.

As mentioned earlier, the city of Los Angeles itself, has made a lasting impression on Chicano artists. Its center-less nodes of activity, stratified economy, social fragmentation, and anything-goes atmosphere, all factor as constructs in Chicano art, pulsing just below the surface. It's in Carlos Almaraz's exploding freeway car crashes, in John Valadez's lonely beach figures, in Patssi Valdez's ornately poignant city window displays.

Each of the precursors discussed above—Siqueiros, graffiti, the *pachucos,* Frida Kahlo, and Los Angeles—has uniquely contributed to the evolution of Chicano art. The results are five-fold:

- A critique of the status quo
- The establishment of a unique aesthetic sensibility—art measured on its own terms
- Visual demarcations between conventionally accepted cultural modes and Chicano values
- Cultural integrity and self-affirmation
- The use of montage—the bringing together of dissimilar elements into a new whole—as an essential technique

Nothing takes place in a vacuum and this is especially true for art created by a long-ignored people

who begin to question their status. As the artist and writer Harry Gamboa, Jr., once put it, "Chicanos are viewed essentially as a phantom culture. We're like a rumor in this country." The Unseen. A phantom population begins to reveal itself to the world.

A Phantom Culture Comes to Life

Most likely, Chicano art was born one day in 1965 when the late labor leader and civil rights activist César E. Chávez gave budding theater director Luis Valdez (who would later produce the play, *Zoot Suit* and direct the Richie Valens biopic, *La Bamba*) the permission to mount raw *actos*, satiric one-acts, on the picket lines of the dusty Delano fields in central California. In what would become a classic example of Chicano ingenuity, artists created a theater out of nothing. As Chávez said at the time, "There is no money, no actors. Nothing. Just workers on strike."

To make something out of nothing became the essence of early Chicano art. While the political struggle was the impetus for the movement, the arts became the means of interpretation and explanation. At the time few artists had attended art institutes and there were no government or foundation grants for ethnic artists. What the artists had was a need to say something about themselves and their community.

Spurred on by the anti-authority zeitgeist of the era, young Chicanos walked out of their substandard schools, protested the Vietnam War, in which a disproportionate number of Chicanos were being killed, and in general, rose up against a long history of injustice. Murals, like giant newspapers, proclaimed it all. Mural art filled a void by covering blank wall space with thousands of murals in housing projects, community centers, schoolyards, church halls, and storefronts. Images and themes were broad—scenes of ancient Mexican ceremonial life, farm workers on strike, blue-cloaked Virgin de Guadalupe, the value of family reading.

The blank wall became *the* space for Chicano art in Los Angeles in the 1970s. They were territorial markers and community billboards because Chicanos didn't own newspapers or radio and TV stations. To tell their stories, muralists engaged their community. Before applying paint to a wall, Chicano muralists would talk with the people who lived and worked in the area, and in so doing the artists enlisted the support of the community.

Many well-known Chicano painters such as Carlos Almaraz, Gronk, John Valadez, and Margaret García started out as muralists. One artist, Judithe Hernandez, has explained: "We tried to make murals into cultural billboards." As Willie Herron said about one of his untitled murals which shows a being who is half skeleton and half throbbing heart, "It is about the tear of two cultures, the feeling of violence and of being ripped apart by them." Whatever the actual content, Chicano murals became a form of lively dialogue between artists conveying the word about a new social revolution and a community eager to learn about it in broad strokes.

The Chicano murals of the late 1960s and early 1970s were a form of social and political literacy. The murals were the texts, the artists were the teachers or the instructors, and the members of the community were the students, readers learning about a movement otherwise ignored in the mass media of the day. Paolo Freire, the Brazilian philosopher and proponent of education for critical consciousness, would have felt right at home on a street in East Los Angeles with giant murals of farm workers and the words "Boycott Gallo" in large letters floating above the bloodshed. That is the true definition of news.

The Birth of the Chicano Sensibility

In Los Angeles, two very different Chicano art groups embodied two of the main community perspectives of the 1970s, a decade that defined Chicano art. Los Four was one of the first major groups to form in the city. It included the late Carlos Almaraz, Gilbert (Magu) Lujan, Roberto (Beto) de la Rocha, and Frank Romero. Later, the collective would count John Valadez and Judithe Hernandez as core members.

The second major art group of the period was Asco (Spanish for nausea). Gronk, Willie Herron, Patssi Valdez, and Harry Gamboa, Jr., were the original members. Other artists joined the group, often on a temporary basis, including Daniel J. Martinez and Diane Gamboa.

Asco and Los Four were inversions of one another. Los Four represented a cool, intellectual approach. Most of its members were schooled in the arts and held degrees, some advanced, from colleges and universities. Almaraz, in particular, represented the theoretical approach. As he once said, "We were opening up the definition of what Chicano was and could be." Valadez explained, "We were so starved for any kind of positive identity that any recognition of who we were, that we were even there, caused a deep response." Asco, on the other hand, symbolized the street and barrio youth. Asco members were self-taught and absorbed everything they could from TV, cartoons, foreign films, and the progenitors of performance art such as Fluxus and Andy Warhol. For Asco, there was a desire to show the truth as they lived it. As Willie Herron liked to say, "We were the true representatives of the street, the real Chicanos who were taking it all the way. We weren't romanticizing or glorifying what the streets were like. . . . We wanted to reach inside and pull people's guts out."

Although Gronk and Herron painted some of the best-known Chicano murals, they also wanted Asco to move toward public performance and spectacle. That might explain why their first major impact on the Los Angeles art world was part-performance, part-mural, employing graffiti as a form of Chicano expression. Even into the 1970s, the Los Angeles County Museum of Art (LACMA) had not exhibited the work of Chicano artists. To protest their exclusion, Asco members went to the museum late one night and spray-painted their names on the outside of the main building. As they later said, "We felt that if we couldn't get inside, we would just sign the museum itself and call it our work."

As the 1970s came to a close, Chicano artists in Los Angeles began to move in different directions. John Valadez, for one, wanted to create images with subliminal messages. He felt that it was important to develop "a way of presenting subversive images" conveyed in a "Latino visual language." With his portable mural, *The Broadway Mural* (1981), which was basically a giant canvas work, Valadez moved full force into Photorealism. The work depicts people walking through Los Angeles's main downtown drag—Broadway between 2nd and 8th streets—a busy, predominately Spanish-speaking shopping district. Wearing everyday cares on their faces and colorful casual dress, the people in *Broadway Mural* mirror the undeniable reality of Mexican Los Angeles. By the early 1980s, Los Angeles, especially the inner city, had been transformed into a Latino city. Basically, the city had been reclaimed by new immigrants, economic refugees from little villages and pueblos in Mexico, and also from poor Central American countries such as El Salvador, Guatemala, Honduras, and Nicaragua.

Valadez's Photorealist "snapshot" of Broadway spoke volumes about the new formidability of the Latin presence in the very city where four decades earlier Mexicans had been beaten and humiliated. At eighty-feet long, it is a monumental example of what Umberto Eco calls "semiotic guerrilla warfare." Valadez's maturity as an artist coincided with the changed reality of the city. A new collective voice had been born.

Chicano artists of the 1970s and early 1980s had invented a "visual language" complete with its own imagery and culturally relevant content. Theirs was a language that spoke to people within the community in terms they could understand. With allusions to Aztec mythology, everyday cultural artifact, police brutality, and gang violence, the art covered the streets of East Los Angeles with enormous marquees of pride. Most importantly, the artists proclaimed the power behind self-definition and political autonomy. As such, they assumed the roles of educator, prophet, and activist. In the process of assuming these commingled roles, the artists transformed one community's dreams into concrete reference points for social change.

Entering the Future Tense

There are certain artists who define a period—Picasso in Paris in the 1920s and 30s, Jackson Pollock and Abstract Expressionism during the late 1940s and early 50s, Gronk and Almaraz in Los Angeles in the 1980s.

Glugio Gronk Nicandro helped create the "underground" of East Los Angeles. Like many other Chicano artists, Gronk survived and flourished by acknowledging and juxtaposing images from two cultures at constant metaphysical odds with each other. His peers in the Chicano community see him as an *auteur.* A surrealist by nature and a polymorphic artist by practice, Gronk's influences range from Daffy Duck to Antonin Artaud, from Marcel Duchamp to the Mexican comic Cantinflas. Gronk and Willie Herron were responsible for some of the most memorable murals created in Los Angeles during the Chicano mural rage of the 1970s. *The Black and White Mural,* which shows excruciating scenes from a police riot in a series of black-and-white panels still exists in the Estrada Courts housing project in East Los Angeles. Others, though now gone, were often the first to show the world the emotional content of barrio life without sentiment or false hopes.

As time moved on and the world changed and became less enamored of ethnic social movements, Gronk changed and adapted, too. Although he has always recalled his street roots, he travels easily with art collectors and denizens of the gallery world. Along the way, he has kept his tongue firmly in cheek. For him, fun is serious business and everything serious is fair game for ridicule. In 1985, Gronk invited the art world, critics, and curious onlookers to take a metaphorical voyage on the ill-fated Titanic. In an exhibition called "The Titanic and Other Tragedies at Sea," he painted images of the mindless frolics of the upper classes and used the concept of the *Titanic,* that manmade folly of the Industrial Age, as a metaphor for the U.S. during the Reagan years. In what would become a recurring obsession for Gronk, he took viewers on a satirical voyeur's tour through a world of opulent excess.

It was also during this period that he perfected his renowned temptress, La Tormenta. Perhaps from her name we can assume that she is the one who torments. Whether it is the artist or the awestruck viewer that she afflicts or both does not matter. She is always the faceless one, her chalk-white back to the viewer, the femme fatale in the backless dress who glides through Gronk's worlds like a specter of reptilian temptation and irresistibility. The case could be made that Tormenta is none other than Gronk himself, his anima, his feminine self, dressed to kill and to impress. (See Panel I of *La Tormenta Returns* for one treatment of this familiar Gronkism, page 76.)

In the late 1980s, he began creating shows around the concept of hotels. In 1988, for example, he put forth "Grand Hotel," the first in a series of exhibitions that used this symbol of life's transitory nature. His initial inspiration was the time that he spent living in the Grand Hotel, a way station in downtown Los Angeles not far from his loft. "I did research," Gronk explained. "I needed to know what it was like to live

there. I had to absorb the essence. You've heard of Method actors, I am a Method painter." The resulting show still found Gronk gnawing away at the edges of high society but also exploring themes and images that he has since honed into a distinctive aesthetic.

In many ways, Gronk reached one high point in his career with his "Hotel Senator" show in 1991. Based again on an actual hotel—the one across the street from his studio home—he sharpened the interplay between medium, form, and content. Hotel Senator was a fleabag hotel frequented by drug dealers, prostitutes, and an assortment of low-lifes. Gronk painted searing images on specially made wooden doors so that they in effect became portals to a world of desperation and heartache.

The signature piece, *Hotel Signature,* from this show is perhaps Gronk's most discerning and riveting take on the disillusionment of our age. It is a translucent midnight-blue entity wearing a grimace of violated pain. The creature stares out imploringly from the painting, its head on fire and its arms spread as in crucifixion. Here is an updated take on Siqueiros's 1932 peasant Indian caught in the violent cross-fire of millennial contradictions and broken dreams.

The late Carlos Almaraz died of AIDS in 1989. In many ways, just as Los Four and Asco were inversions of each other, Gronk and Almaraz were opposites connected at the root. Gronk's exposure to art was in the form of street graffiti and Saturday morning cartoons; Almaraz was struck by the power of a holy image in a church. Both started out as muralists and members of art collectives and both later broke into the fine art world and were represented by major L.A. galleries. The key difference between the two was that while Gronk experimented with various persona and media, including performance and stage presentations, Almaraz was a painter in the classical sense.

Four days after his death in December 1989, Almaraz's family and friends built him an altar—exuberant and melancholy like the artist himself. Los Lobos sent a pink guitar pick. César Chávez sent condolences by telegram. Almaraz had been on the Dalai Lama's prayer list. His death was deeply mourned by many in the L.A. art world. Almaraz once told a friend that he fell in love with art when he was four years old. "My mother would take me to church and there was a painting of John the Baptist—with a long beard, long hair, bushy eyebrows, all draped in fur. I really believed that it was a gorilla, and it scared me. This was my first impression of art, something both horrifying and absolutely magical."

Dichotomy was to mark his work and his sensibility. To create his own iconography, he combined the influences of Western European and American art—everything from Paul Klee to Cy Twombly as well as to Walt Disney and other American filmmakers—with barrio imagery. His paintings and pastels gained a new urgency in the 1980s. He also delved into his own sexual duality. In *El Verde/The Green One*, Almaraz shows us an ominous, horned green devil that stands as the tempter with a slip of silk purple cloth hiding his most titillating and deadliest temptation. Almaraz used to say that, "We're surrounded by spiritual disease and AIDS is just the symbol of that plague."

Hegal wrote, "sense loses itself in intuition." In much of Almaraz's work, there is the unashamed rejection of rationality. He took his artistic impetus not only from intellectual construct but also from visual intuition. His genius was in his ability to depict with utter clarity that which lies behind reality—the bliss as well as the dementia that come with unconscious urges, the pleasure and the torment that are born of forces prowling around us, uncontrollable and insistent.

The Echo Park series is a perfect example of this. Superficially, it's hard to explain the horror inherent in the apparently romantic tranquility of the park. But when you know the environment in its real context, bordered on all sides by anxiety, poverty, and oppression, the graceful images become omens of impending chaos. Almaraz foretells a dark fate lurking in the shadows and beneath the surface.

Duality permeates Almaraz's dream world. He pushes to the furthest limit (and in the process blurs) the distinctions between male and female, sin and salvation, the obvious and the barely perceptible. Even his color palette—blood red, midnight blue, burnt orange, royal purple—suggests this.

Gronk and Almaraz exemplify the constant evolution of Chicano art. Their work and the work of their contemporaries, among them John Valadez, Carmen Lomas Garza, Leo Limón, Patssi Valdez, César Martínez, and Frank Romero, has postulated an inimitable cultural vision based on the idea that the exilic impulse and a prolonged state of ambiguity is a natural human condition worthy of our attention and regard.

Healing the Wounds

In the pastel painting *Immamou* (1992), John Valadez created an image of Chicano self-excavation: A headless, naked torso with Kahlo-esque cuts, bruises, and hieroglyphic tattoos, is submerged in murky, troubled water. The sunken body is waist-deep in the waste of a distressed post-modern society. This is the region of the unconscious, a site of desires unnamable and unknown. *Immamou* is the wounded survivor, the Chicano/a who triumphs despite the accumulated weight of history. This is the inner self, proudly displaying its spiritual damage and the markings of its ritual healing. Like the images of the wounded in Valadez's *Getting Them Out of the Car*, there is a sense that we need ritual in our lives and spiritual imagery in order to restore our physical health and our cultural legacy.

The healing does come, for instance, in Patssi Valdez's painting, *Little Girl With Yellow Dress*. Valdez presents a young brown girl, dressed up for a special occasion. The figure in the painting could very well be the cousin of one of Carmen Lomas Garza's *monitos* (little dolls or little people). The hesitant expectation in her stance, along with the slanting geometric shadows and the lonely blue ball on the sidewalk, are reminiscent of Lomas Garza's memory of being a little girl who spoke with a thick Spanish accent in an English-language world: "I, too, suffered many physical and emotional punishments," Lomas Garza once wrote. "Each time I spoke English I was ridiculed for my accent and made to feel ashamed."

This lament, like the elegies of the vanquished Aztecs shortly after the Conquest, has been transformed into art by generations of Chicano artists. The healing of wounds, ancient and new, and of the basic suffering of life will continue as long as artists create a visual salve for the hurt.

According to Chicano mythology, wholeness will come again when Chicanos inherit Aztlán, their promised land, the place where they will find cultural and psychic unity. Until that day comes, Chicano artists will continue to create an Aztlán of the imagination, a memorable counterpoint to the mass hypnosis of our age.

Bibliography

Benavidez, Max. "Carlos Almaraz: 1941–1989, A Remembrance" in *L.A. Style,* January 1990.

———. "Chicano Montage: Art and Cultural Crisis" in *Distant Relations: Chicano, Irish, Mexican Art and Critical Writing.* New York: Smart Art Press, 1996.

———. "Gronk: Master of Urban Absurdity." Exh. cat. San Francisco: Mexican Museum, 1994.

———. "Mural L.A.: The Rise and Fall of a Popular Art" in *Art Issues Journal,* 1995.

———. "John Valadez: The Schizo-Ethnic View" in *Los Angeles Times,* November 29, 1992.

Benavidez, Max and Kate Vozoff. "The Wall: Image and Boundary, Chicano Art in the 1970s" in *Images of Displacement.* Vanderbilt University, 1982.

The Diary of Frida Kahlo, An Intimate Self-Portrait. New York: Harry N. Abrams, 1995.

Hooks, Bell. *Reel to Real: Race, Sex and Class at the Movies.* New York: Routledge Press, 1996.

Leon-Portilla, Miguel, ed. *The Broken Spears: The Aztec Account of the Conquest of Mexico.* Boston: Beacon Press, 1992.

Said, Edward W. *Culture and Imperialism.* New York: Alfred A. Knopf, 1993.

Thomas, Hugh. *Conquest: Montezuma, Cortes, and the Fall of Old Mexico.* New York: Touchstone Books, 1993.

Villaurrutia, Xavier. *Nostalgia for Death.* Port Townsend, Wash.: Copper Canyon Press, 1993.

MESTIZA AESTHETICS AND CHICANA PAINTERLY VISIONS

By Tere Romo

Because I, a mestiza,
continually walk out of one culture
and into another,
because I am in all cultures at the same time.
—Gloria Anzuldua

The Chicano Movement of the late 1960s and 1970s also marked the beginning of Chicano art as artists abandoned individual careers and became the visual articulators of the movement's political agenda, mainly through the creation of posters and murals. By articulating the movement's political stance, artists also had as their central goal the formation and affirmation of a Chicano identity. "Self-representation was foremost in that phenomenon, since self-definition and self-determination were the guiding principles . . . of a negotiated nationalism."[1] In visualizing this new identity, artists became part of a cultural reclamation process that expanded the definition of Art to include all the arts that affirmed and celebrated their Mexican cultural heritage, including pre-conquest symbols, religious icons, popular art forms, murals, and graphic arts.[2] The result was an iconography of new images and symbols derived from a Mexican *mestizo* (mixed race) heritage, yet forged within an American, bicultural experience.

Patssi Valdez. *Autumn.* **2000 (detail)**

As a result of this syncretism a distinctly Chicano aesthetic emerged, much of it during the first decade tied to a nationalist, political agenda. The early iconography combined easily identifiable heroic figures with images from a glorious past and transformed them into artworks that were relevant and culturally affirming. From its inception, Chicano art was heavily male-dominated and this was reflected in the predominant imagery. "At that time, a lot of the images were of men," recalled visual artist and muralist Irene Perez. "All the heroes were men and it seemed like historical events only happened to men, not to families or communities."[3] Although the movement's leaders called for ethnic and racial equality, the need for gender parity in the areas of leadership and decision-making was often overlooked. Within the Chicano Art Movement, artist collectives and centers were overwhelmingly male. Those that did include women usually had one or two members and none of them in leadership positions. As artists, Chicanas found themselves contending not only with the mainstream's patriarchal system, but also with the movement's own brand of machismo.[4]

Chicana artists turned their exclusion into an advantage as they pursued their own artistic path and visibility. From the beginning, as Chicano artists strove to utilize art as an active tool of socio-political mobilization, propaganda, and empowerment, Chicana artists chose a less conformist approach to art making. Chicanas also tackled gender politics. Consequently, subject matter such as motherhood, regeneration, and female ancestry became part of a formal and ideological basis for a Chicana aesthetic in the early years of the Chicano Art Movement.[5]

As Chicana artists continued to experiment with different media and iconography, they found themselves outside the definitions of Chicano art as constructed by males. Chicana art was perceived as non-political (lacking a political message), too personal (rather than community focused), and pro-religion (too Catholic). However, a closer reading of Chicana art reveals the same principles underlying Chicano art: political resistance, cultural affirmation, and bicultural identification. As women, Chicanas also asserted their right to create an art meaningful to them. According to scholar Amalia Mesa-Bains,

> The work of Chicana artists has long been concerned with the roles of women, questioning of gender relations, and the opening of domestic space. Devices of paradox, irony, and subversion are signs of the conflicting and contradictory nature of the domestic and familial world within the work of Chicana artists.[6]

Through a conflation of subversive imagery, content (message) and art process, a distinctive Chicana aesthetic evolved that was grounded in Chicano ideals and artistic integrity, yet molded by a conscious resistance to restrictive so-called female roles as defined in relation to male needs, desires, or projections. Feminist theorist Griselda Pollack writes, "The spaces of femininity . . . are a product of a lived sense of social relatedness, mobility and visibility in the social relations of seeing and being seen."[7] Having begun with the recuperation of their feminine persona with materials and scenes from the domestic sphere, by the late 1970s Chicana artists freely explored a myriad of media and fully exploited metaphorical and ironic elements within their art. Some Chicana artists experimented with installation art, photography, performance art, box constructions, and other art forms that expanded their abilities to rework and reconstruct identity utilizing familiar materials. An example of this was the transformation of private home altars into contemporary public art installations by Amalia Mesa-Bains, Carmen Lomas Garza, and Patssi Valdez, among others.

Even within the seemingly safe world of painting, Chicana artists defied the mainstream's art canon

in the creation of their own *mestiza* aesthetics. An excellent representation of these distinct aesthetics can be seen in the artwork of the Chicana painters featured in the following pages. There are similar experiences that unite Diane Gamboa, Margaret García, Carmen Lomas Garza, Ester Hernández, Marta Sánchez, and Patssi Valdez. They are all from working-class families and born roughly within the same decade. Each artist has had some art school training and most of them have received fine arts degrees. Understandably, major differences inform their artwork. Valdez, Gamboa, and García were born and raised in the urban environment of East Los Angeles. Hernández was born in California's rural central valley into a migrant farm worker family. Garza and Sánchez are both from South Texas (Kingsville and San Antonio, respectively). While it is true that Garza, Hernández, and Sánchez left their places of birth to pursue higher education and live in major cities (San Francisco and Philadelphia), their early regional influences are key to an understanding of their art. This geographic balance provides a good grounding for the discussion of the work of each of the painters and a point of departure for each artist's contribution to what I call "*mestiza* aesthetics of clarity."

The search for artistic clarity is hardly a new concept for painters. From its early beginnings on cave walls, painting has struggled to articulate what an artist deems important. This is the clarity that belongs to the surrealists' attempt to make the unconscious visible or Rothko's attempts to paint God. The *mestiza* aesthetics of clarity as honed and practiced by Chicana painters, however, are based on the visual transformation of their socio-political and gender experiences driven by their artistic vision. Rather than a prescribed search for beauty, or an "art for art's sake," their aesthetic is based on the *process of making clear that which by definition is melded.* For these painters, the creation of their art is the exposure of imperfections, whether it is ethnic stereotypes, gender restrictions, or personal demons in order to provide a more inclusive and cohesive understanding of another valid reality. In the course of their artistic explorations, they have created their own visual language of cultural resistance and personal transformation.

The artists represented here paint in styles ranging from near abstraction to realism, yet all their work can be described as variations of portraiture. As metaphoric self-portraits or realistic recreations of community activities, this portraiture becomes a form of cultural survival and personal regeneration. In fact, for these Chicana artists there is no distinction between the importance of art in personal and community survival. To express her vision is to bring visibility to not only herself and her artistic voice, but also to the community that the Chicana artist is a part of and represents.

Urban Reflections Through the Chicana Looking Glass: Patssi Valdez, Diane Gamboa, and Margaret García

Los Angeles has the distinction of being one of the largest cities in the United States and the birthplace of the Hollywood industry that continues to impact the world. Los Angeles is also home to the largest concentration of Mexicans outside of Mexico. It has been noted that someone can live in Los Angeles all his or her life and never have to learn English. During the Chicano movement, L.A. was an epicenter of political mobilization by students, Vietnam anti-war demonstrators, and labor activists. It was during this volatile period of the Brown Berets' formation, high school student walkouts, United Farm Workers Union picket lines, and the Chicano Moratorium that Patssi Valdez, Margaret García, and Diane Gamboa found their artistic voice.

Patssi Valdez began her art career as a member of the seminal group Asco while still in high school.

Along with three male members (Harry Gamboa, Gronk, and Willie Herron) she created murals, photographs, and conceptual and performance art. Though Asco had its beginnings within the Chicano Movement, their work not only questioned the societal and institutional racism of Los Angeles but also the essential identity of cultural nationalism.[8] In the shadow of Hollywood, East Los Angeles proved fertile ground for Asco's engagement in a social and gender critique of the media, its role in the formation of ethnic, and, in the case of Valdez, female identity. For Valdez, Asco provided the opportunity to refute the confining and unflattering images of Chicanas held by the larger society.

During her career as an artist, Valdez worked in fashion design, mixed media art, photography, theater and movie set designs, and installations. However, it is painting to which she has returned repeatedly to re-create and redefine herself. To some extent, all of Valdez's art has been autobiographical. She has used objects metaphorically to represent various experiences of her life, "vibrations" created by complementary colors to express her emotional states. Her aesthetic is built on a search for personal clarity through her metaphysical connection to painting. "Painting is so special," says Valdez, "because it is imbued with the person's essence and the painter's energy."[9]

Autumn (2000; page 139) is an excellent example of Valdez's mastery of color theory and her portrait-as-metaphor style. Here Valdez combines the predominant indoor scenes of her earlier paintings with her more recent outdoor landscapes. The room's central image is a table on which rests a birthday cake with lit candles, glasses of wine, a fork, and knife. The actual room is minimal, given the open door and window taking up much of the painting. Through these openings we see a placid lake with mountains in the distance and a full moon. The only obstruction to this scene is a wall with religious figures, including a small altar. The genteel vista is in contrast to the implied movement in the foreground, where the table legs spread out as if giving way under the weight of the objects on top. The golden-colored autumn leaves stream in through the window and door, filling the middle space with movement as well. An empty chair waits off to the side.

The ambiguity of the multiple elements in this domestic scene raises the psychic tension inherent. (For example, where are the party guests?) The falling leaves and painting's title — *Autumn* — references the coming of winter and the end of another year. The overall sense of calm and optimism triumphs, with spiritual assurance as a counter to personal doubts. The seasonal metaphor, by which autumn begets winter, forecasts the promise of rebirth in the spring. The painting also becomes a visual testament of the gradual dissipation of the personal turmoil that had informed much of Valdez's early artwork.

Diane Gamboa's art also draws from the urban realities of growing up in East Los Angeles, in her case in a family of five children. Gamboa received indirect artistic encouragement to pursue her artistic interests from her father, a graphic artist and printer. However, by the time she was sixteen, Gamboa was in high school, married and struggling to keep painting. It was her brother Harry who introduced her to the Chicano Movement, where she found other artists with whom she could collaborate and interact creatively.[10] In 1980, she joined Asco as a stylist and makeup artist for photos, performances, video, and films. Though she studied at Otis Art Institute for two years, she considers herself a self-taught painter.

Much of Gamboa's aesthetic reflects her participation in the Los Angeles punk scene. From 1976 to 1982, Los Angeles was a vortex of punk music and art. "A central theme in punk — now often called hardcore — has been individualism, anti-authoritarianism, a Do-It-Yourself philosophy that encourages action instead of apathy."[11] East L.A. had its own version fueled by the music of The Brat, The Plugz, and Los Illegals, punk groups that added political subject matter to their music. Gamboa was one of the insiders who photographed this historical period and channeled its intensity in her paintings. For Gamboa, the

edgy angst of the punk scene resonated with her need to express the "obscure things, things not clearly understood and the painful."[12] It was also important to Gamboa to portray this segment of the community, which was as much a part of the Chicano youth culture as the *pachuco,* cholo, or low-rider.

Gamboa's internalized urban experiences explode from the canvas and push the boundaries of Chicano art. Her paintings are full of raw emotion, tinged with a sexual edge and often tempered with humor and irony. She populates her artistic world with an array of distorted human figures depicted in flat, garish colors and with sharp features and body tattoos. These portraits of couples, family life and individuals in everyday scenes are rendered in a shocking, exaggerated style, to the point that they become less human and more like the surrounding inanimate props. Seemingly ordinary occurrences are reconstituted on canvas as scenes from a dream, a bizarre cartoon, or a "Twilight Zone" television episode, which Gamboa cites as a major artistic influence.[13]

Tame a Wild Beast (1991; page 62) is an excellent example of one of these bizarre scenes. Here, Gamboa captures a couple in their bedroom during "intimate moments between two consenting adults."[14] The intensity of the scene is heightened by the use of dark contrasting reds and blues and the poses of the figures locked in a gaze. A tense drama is created by the baroque-like quality of the furnishings, the addition of a red devil mask on one of the chairs, and in the barely discernable outline of another male figure behind the woman. Though the man and the woman directly interact, a strong element of mystery is pervasive. Even the "wild beast" of the painting's title is never completely defined. It could be any of the protagonists, the mysterious "red man" on the wall, or the sexually charged energy that permeates the painting. It could even be the viewer as voyeur in this ambiguous drama.

Margaret García grew up in the Boyle Heights neighborhood of Los Angeles and credits her grandmother, whom she lived with after she turned fourteen, with cultivating her artistic talents. Though she studied drawing at East Los Angeles College, like García she considers herself a self-taught artist. It was while supporting herself as a studio model that she learned portraiture painting by posing for other artists in exchange for letting her paint them.[15] In the mid-1970s, García, who by now was married and had a daughter, moved to Chicago. When she moved back to L.A. in 1983, she met Chicano artists who introduced her to the growing art scene and provided her with an important support system of artists and activists.

If Valdez's and Gamboa's portraits are documentation of internalized urban experiences that come into focus through personal metaphor and social commentary, respectively, then García's paintings are the external manifestation of portraits as historical documentation. She has made a commitment to the creation of a visual record of her community, especially strong women and artists. However, rather then being realistic, García's portraits are expressive compositions that employ bright colors and strong lines.

In her ongoing series titled *Un Nuevo Mestizaje* (begun 1987; page 68), she celebrates the racial range of the Mexicano/Chicano community. "I have been documenting my community one at a time," declares García. For her, it is important "to be able to reveal the individual within the community. To see us one at a time, without clichés or stereotypes. To know there are filmmakers, and authors and artists and not just sleeping Mexicans, gang bangers, and all the other negative stereotypes the media has provided."[16] Her series also contributes significantly to the understanding and acceptance of the various racial mixtures that constitute the Chicano community, including our African and Asian heritages. With its indirect reference to the Mexican colonial paintings known as *castas,* which documented the different names given to various racial combinations, *Un Nuevo Mestizaje* provides a contemporary, Chicano version. Rather than being a stratified racial coding instrument, García's series renders a personal and loving tribute to the survival and pride of the community in all its racial combinations.

The Art of Female Provocation, or in other words, Ester Hernández

As the creator of some of the Chicano art movement's most iconic images, including *La Virgen de Guadalupe defendiendo los derechos de los Chicanos* (1975), *Libertad* (1976), and *Sun Mad* (1982), Ester Hernández has made a life-long career of political and feminist provocation. She is best known for her graphic work, especially serigraphs focusing on women, farm workers, and environmental issues— all important elements from her childhood as a member of a migrant family working in the fields of California's central valley. In the early 1970s, Hernández moved to the San Francisco Bay Area to study art. It was there that she became involved in the Chicano Movement, including the United Farm Workers Union struggle. In the late 1970s, she joined Las Mujeres Muralistas, an all-women collective that celebrated the contributions of women and families in their murals.[17]

As a result of her childhood experiences among strong female role models, especially her mother, sister, and grandmother, Hernández focuses on the portrayal of women as one of her main themes. Her portraits have included self-portraits, female members of her family, UFW activists Dolores Huerta, acclaimed singer Lydia Mendoza, and working women of San Francisco's Latino Mission District. According to Hernández, "I have created my own *familia,* community Through drawing them I have captured some of their spirit."[18] Her choice of women has been a conscious effort to not only render them visible, but to elevate their status to that of role models. Hernández's women have broken restrictive roles in order to either pursue better economic opportunities and/or careers, to serve their community better, or simply to fulfill personal goals. According to Mesa-Bains, this questioning of female roles, particularly "hyper-idealized family roles which have been restrictive and limiting," has been one of Chicana artists' major contributions.[19]

Some women in Hernández's portraits transgress all the restrictive gender rules. The outrageous Mexican performer and singer Astrid Hadad is legendary in her subversive, but very entertaining attacks on female stereotypes, Latin American popular culture, the Mexican government, and United States neo-imperialism. In Hernández's pastel, *Astrid Hadad in San Francisco* (1994; page 92), the artist captures Hadad's larger-than-life stage presence and what she describes as her "flamboyance, power and sense of humor." In this portrait, Hadad is depicted in an elaborate costume during a dramatic moment in her performance, conveyed by her expression-filled face and her upraised arms. One can also see Hernández's remarkable ability to combine the political with the celebratory. Hadad's stark image against the empty black background elevates her to icon status and, and by extension exalts her sacrilegious agenda. In choosing to portray a *Mexicana*, Hernández also unifies the Chicana struggle for social and gender equality with that of Mexican women. Consequently, Hernández transforms Hadad into a Chicana role model and creates a testament to the power of all women who practice their own brand of provocation.

Rituals of Memory: Carmen Lomas Garza's "Monitos" Paintings

The paintings of Carmen Lomas Garza draw from multiple cultural, artistic, and personal sources derived from her childhood experiences in Kingsville, Texas. Growing up in rural South Texas afforded Garza a close family and community environment, but also exposed her on a daily basis to stifling poverty and overt racism. At the age of thirteen she decided to pursue a career as a visual artist, which her parents

encouraged. She also received inspiration from her mother, a self-taught artist who painted *loteria* (Mexican bingo) cards. It was while at Texas A&I, Kingsville, that she encountered the Chicano Movement, which she recalled, "inspired the dedication of my creativity to the depiction of special and everyday events in the lives of Mexican Americans based on my memories and experiences in South Texas."[20] This prolific artist and avid experimenter has produced etchings, lithographs, paintings, children's books, altar installations, *papel picado* (paper cutouts), and metal sculptures from her reservoir of memory. In Garza's art, memory becomes a conscious strategy of personal resistance and cultural affirmation, which, according to scholar and curator Victor Zamudio-Taylor, can "undo and cure the wounds of social amnesia."[21]

Garza's narrative paintings are reminiscent of Mexican *retablo* paintings, yet unique in an artistic style crafted by her academic art training. Though the figures have a flat, two-dimensional quality, they are rendered in motion by Garza's subtle shading technique and their placement on the canvas. Garza's use of the shallow picture space also heightens their emotional quality and lends a feeling of participation as the viewer is literally thrust into the scene. In her paintings, the conceptual (memory) and the perceptual modes of visual expression are joined, creating a seamless juncture of her personal ideas, cultural concepts, and the natural world.

The painting *Una Tarde/One Summer Afternoon* (1993; page 73) is representative of Garza's style of "intimate storytelling."[22] It depicts a bedroom scene with a young couple talking to each other through a window screen. Garza inserts herself as a small child seated on the floor playing with the bedspread fringe. Her grandmother, the chaperone, knits in a chair close by, while a mother cat suckles her kittens in the foreground. In this portrayal of a traditional Mexican courting ritual, the viewer focuses on the couple and the vigilant grandmother. Other important, subtle references add to the painting's sense of intimacy, including the small altar to the Virgin of Guadalupe with a statue of the regional *curandero* (healer), Don Pedrito Jaramillo, family portraits on the wall, and a doll on the bed's pillow. Garza has also added a humorous touch with the two fishes blowing bubbles (conducting a courtship of their own?) on the upper right corner of the wall. The bright yellow of the room's walls and the flowers that bloom outside the windows accentuate the joyful, life-affirming qualities of this cultural and community rite of passage.

In this painting, as in all her art, Garza reaffirms the power of personal memories as a means of documenting and maintaining a community history. According to Ybarra-Frausto, "Visual episodes within an unfolding epic tale of cultural regeneration, (Garza's) *monitos* keep alive the customs and daily practices that give meaning and coherence to Chicano identity."[23] This visual recounting of stories, myths, and memories from a cohesive familial and supportive social environment, are Garza's testimonies to an often overlooked and equally subversive form of cultural resistance.

Marta Sánchez: A Spirituality of Resistance

Marta Sánchez was also born and raised in south Texas, in San Antonio, as part of a large family that battled poverty and racism. From an early age, she found art to be "a voice for what I could not express in words."[24] Her interest in art led her to seek an art education degree at the University of Texas at Austin, which Sánchez later changed into a BFA. It was there that she met Santa Barraza, an artist who introduced her to the Chicano movement. After receiving her degree in painting, Sánchez enrolled in the MFA program at the Tyler School of Art in Philadelphia, attracted by their incorporation of a year of study abroad as part of their curriculum. After graduation, Sánchez remained in Philadelphia where she currently resides.

It was during her year in Italy that Sánchez saw an installation of paintings on tin that provided the impetus for her artistic explorations of the Mexican religious *retablos* (also known as ex-votos). These small paintings on tin are traditionally commissioned out of gratitude to a favorite saint for a granted request. Aside from striving for aesthetic quality, *retablos* relate the story of the miracle visually, along with a brief narration. These paintings are usually installed on the walls of a church in order to publicize the miracle, thus "paying off" the debt to the saint. Many Chicano/a artists were attracted to these devotional paintings not only as objects of a Mexican artistic heritage, but also as symbols of personal hope and spiritual healing. For Sánchez, *retablos* provided the perfect artistic medium to explore her identity and to re-evaluate the spiritual aspects of her religious beliefs. "I was first and foremost a Mexican, but inside I had even more layers to peel, including community and social issues regarding our Spanish, Indigenous, and Catholic backgrounds."[25] In her surprising combinations of disparate images, Sánchez's paintings convey a fascinating range of meanings.

La Danza (1994; page 120), which draws on the traditional *retablo* style for its visual references, creates an expressionist tale of a personal odyssey. Defined by Sánchez as "an autobiographical ex-voto for myself," she is represented as the central almost ghostly, female figure that occupies the majority of the picture frame. All the images in the ex-voto are scenes on her body or else literally revolve around her. In a pose very reminiscent of religious Madonna-and-child portraits, Sánchez's head is rendered looking down with eyes closed, holding a bowl of fruit in her arms. Various scenes emerge from her outlined body, including her childhood home with a heart floating in front, various family members, and a small train. Near her throat, her father is depicted walking down the street, while singing a song. Lush green leaves and flowers fill the spaces outside the outlined figure, which along with the bright colors of the fruit give the *retablo* a feeling of celebratory confidence. Even the snarled vegetation in the background, which creates a sense of swirling chaos, is kept at bay by Sánchez's positive childhood memories.

Especially telling is the text that Sánchez has chosen to recount her story: *"La danza insegura de mi familia"* (The insecure dance of my family) and *"el camaron que se duerme, se lo lleva la corriente"* (The shrimp that falls asleep is sweep by the current). Both sentences allude to the impact of her family's financial instability on her emotional state during her childhood. *La Danza* functions as a traditional *retablo* image of offering gratitude for personal survival, but as a contemporary Chicana ex-voto, it is dedicated to her family and culture instead of a Catholic saint. Thus, Sánchez's *retablo* paintings constitute what Ybarra-Frausto has described as "new forms of spirituality (that) reverberate with the presence and potency of an ancient ethos expanded with modern signification."[26] As seen again and again, in reclaiming the religious world and transforming it into contemporary spirituality, Chicana artists also create artistic spaces that unify personal healing with cultural resistance.

Over the course of the Chicano Art Movement, the visual unification of Mexican-American political activism, Mexican cultural identity, and individual artistic exploration has produced iconography that is distinctly Chicano. As defined by art historian Jacinto Quirarte, Chicano artists were "primarily articulating a Chicano identity." They were not interested in self-expression or personal recognition, but in "responding to the needs of the community as defined by the Chicano Movement."[27] Inadvertently, this narrow definition came to exclude the art of many Chicana artists, which was deemed too personal and lacking a political thrust. In fact, however, Chicana artists not only persevered in their exploration of memory, history, resistance, healing, and spirituality, the quality of their work demanded acceptance and inclusion. It was this fusion of the Chicana artist's personal expression with cultural survival that produced a *mestiza* aesthetic in which the movement's political agenda was expanded to include gender

issues. "Whether these depictions are self-portraits, 'ordinary women' as political activists, warriors, and farmers, or historical/religious figures, virtually all of them represent qualities beyond the personal and/or mundane. They are archetypal signifiers of cultural identity and remembrance, political action, spiritual belief and practice, transformation, resistance, struggle, (re)constitution, and presence."[28]

The *mestiza* aesthetics of clarity have afforded Chicanas artistic control and personal power. It is this struggle toward gender equality, cultural affirmation, and spiritual healing in which each artist has found her artistic voice. However, it was through a process of artistic exploration and gender subversion camouflaged within seemingly innocuous domestic scenes and apolitical feminine images that Chicana artists formed their own aesthetic. More importantly, even as an evolving aesthetic continually driven by the visual transformation of their bicultural experiences, it remains firmly grounded in the clarity of their artistic vision.

Notes

1. Freida High, "Chiasmus—Art in Politics/Politics in Art: Chicano/a and African American Image, Text and Activism of the 1960s and 1970s," in Phoebe Farris-Dufrene, ed., *Voices of Color: Art and Society in the Americas* (New Jersey: Humanities Press, 1997), 121.

2. Ramón Favela, *Chicano Art: A Resource Guide, Proyecto CARIDAD* (Chicano Art Resources Information Development and Dissemination). (Santa Barbara: University of California, California Ethnic and Multicultural Archives/CEMA, 1991), 2.

3. Theresa Harlan, "My Indigena Self: A Talk with Irene Perez," exh. brochure *for Irene Perez: Cruzando la Linea*, (Sacramento: La Raza/Galeria Posada, 1996), n.p.

4. A notable exception was La Raza Graphics Center in San Francisco, which had artist Linda Lucero as its director from 1983–1989.

5. Alicia Gaspar de Alba, *Chicano Art Inside/Outside the Master's House: Cultural Politics and the CARA Exhibition* (Austin: University of Texas Press, 1998), 133.

6. Amalia Mesa-Bains, "Domesticana: The Sensibility of Chicana Rascuache" in *Distant Relations: Chicano, Irish, Mexican Art and Critical Writing* (New York: Smart Press, 1995), 162. Mesa-Bains has defined Chicana art as *domesticana Chicana* in which "the creation of a familial space serves as a site for personal definition for the artist. Their work takes on a deeper meaning of domestic tension as the signs of making do are both the affirmation of the domestic life and a challenge to the subjugation of women in the domestic sphere. This domestic tension signifies the contradiction between the supportive aspects of the feminine and the struggle to redefine restrictive roles."

Mesa-Bains developed this term as a complement to Tomás Ybarra-Frauto's *rasquachismo*: "Very generally, *rasquachismo* is an underdog perspective—*los de abajo* . . . it presupposes a world view of the have not, but it is a quality exemplified in objects and places and social comportment . . . it has evolved as a bicultural sensibility" in which "the irreverent and spontaneous are employed to make the most from the least. In *rasquachismo*, one has a stance that is both defiant and inventive." It usually involved creating art from discarded materials.

7. Griselda Pollack, *Visions and Difference: Femininity and the Histories of Art* (New York: Routledge, 1988), 4–5.

8. Gaspar de Alba, 148.

9. Lorenza Muñoz, "A Painter's Great Escape" from *Los Angeles Times,* Sunday, March 7, 1999.

10. Sybil Venegas, Image and Identity: Recent Chicana Art from "La Reina del Pueblo de Los Angeles de la Porcincula," exh. cat. (Los Angeles: Loyola Marymount University, 1990), n.p.

11. José Palafox, "Screaming Our Thoughts: Latinos and Punk Rock," *ColorLines*, August 22, 2000.

12. Venegas, n.p.

13. Holly Barnet, "Where are the Chicana Printmakers*?*" *Just Another Poster?: Chicano Graphic Arts in California* (Santa Barbara: University Art Museum, 2001), 148.

14. Diane Gamboa, artist statement, December 10, 2001.

15. Venegas, n.p.

16. Self-Help Graphics Website: "shgmaestras4". (www.azteca.net/aztec/chicano.html)

17. Las Mujeres Muralistas collective was initially composed of Graciela Carrillo, Consuelo Mendez, Irene Perez, and Patricia Rodriguez, who worked on their first and only joint mural in 1974. Though the core group remained together for only two years and an expanded group of seven painted murals for six years, their impact on Chicano muralism was significant, both aesthetically and historically.

18. Holly J. Barnet, "Transformations: The Art of Ester Hernández," exh. cat. of same title (San José: MACLA/San José Center for Latino Arts, 1998), n.p.

19. Amalia Mesa-Bains, "Art of the Other Mexico: Sources and Meanings," exh. cat. of same title (Chicago: Mexican Fine Arts Center Museum, 1993), 32.

20. Artist statement for exhibition.

21. Victor Zamudio-Taylor, "Contemporary Commentary" in *Ceremony of Memory: New Expressions in Spirituality Among Contemporary Hispanic Artists* (Santa Fe: Center for Contemporary Arts, 1988), 18.

22. Mesa-Bains, *Domesticana*, 163.

23. Tomás Ybarra-Frausto, "Lo Real Maravilloso," exh. cat. of same title (San Francisco: The Mexican Museum, 1987), 7.

24. Conservation with artist, January 12, 2001.

25. Artist 's correspondence with Rene Yañez, exhibition curator.

26. Tomás Ybarra-Frausto, "Cultural Context" in *Ceremony of Memory: New Expressions in Spirituality Among Contemporary Hispanic Artists* (Santa Fe: Center for Contemporary Arts, 1988), 12.

27. John Beardsley and Jane Livingston, *Hispanic Art in the United States: Thirty Hispanic Painters and Sculptors* (New York: Abbeville Press, 1987), 57.

28. Holly Barnet, "Where are the Chicana Printmakers?," 120.

AZTLÁN IN TEJAS: CHICANO/A ART FROM THE THIRD COAST [1]

By Constance Cortez

The concept of Aztlán [2] was introduced during the 1960s as both a geographic and a symbolic locale around which Chicanos/as could rally. It quickly became a conceptual driving force behind much of the art produced during this era, especially in California. Even so, aspects of Aztlán had resonance throughout the Southwest. The Aztlán addressed here is located far from California—it is the Aztlán of the "Third Coast." The phrase *Third Coast* requires some explanation, since it is not used outside of Texas. As the thinking goes, there is the East Coast, there is the West Coast, and there is Texas, the Third Coast, which faces neither the Atlantic nor the Pacific oceans. Rather, it faces the Gulf of Mexico. Texas and its inhabitants share waters as well as borders with Mexico. Beyond that, the state's past and present are inextricably joined with that of Mexico's.

As in the case of Mexico, there is no one Texas. Bravado aside, the fact remains that TEXAS-IS-A-REALLY-BIG-PLACE. The intracultural diversity between Chicano populations is as marked, if not more marked, than that existing between Los Angelino and San Franciscan communities. These regional differences, as well as differences in personal visions, provide the bases for radically different art styles among the

Adan Hernández. *Sin Título II.* 1988 (detail)

33

artists living in the Lone Star State. Nonetheless, there are aspects of a shared experience which link artists and give their works a decidedly Tejano flavor.

Like their counterparts in California or in other parts of the Southwest, much of the visual and written art forms produced by Tejanos/as can be understood as an extension of the struggles and discourses of the Chicano Movement of the 1960s and 70s. A basic paradigm of Aztlán is conveyed in the art produced during these years. Yet, while one can easily observe the iconographic vocabulary that draws on Aztlán's ancient mythohistory, it is the modern understanding of Aztlán that seems to be relevant to Texas artists.

Luis Leal outlined the ancient and the modern aspects of Aztlán in what is now regarded as a seminal article on the subject. According to Leal, the ancient symbolism involves, "the image of the cave (or sometimes a hill) representative of the origin of man; and as a myth, [Aztlán] symbolized the existence of a paradisiacal region where injustice, evil, sickness, old age, poverty, and misery do not exist."[3] Leal also provides us with an additional definition for Aztlán that has two modern components: First, he states that Aztlán was and is the actual geographic region known as the Southwest. This territory is made up of the land that was ceded by Mexico to the United States after the signing of the Treaty of Guadalupe Hidalgo in 1848. The second component of his definition is the more important one for Leal. According to him, Aztlán "symbolized the spiritual union of the Chicanos, and is something that is carried within the heart, no matter where they may find themselves."[4]

My position is that the notion of geographic territory and the negotiation of that territory is foremost in importance for many artists working within Texas. In other words, Aztlán is not just the land, it is the economic, political, and spiritual journey through that land. It is the journey's memory, and the recounting of that memory, that we find in the art of many Tejanos/as. This is especially true for some of the artists from South Texas, San Antonio, and West Texas.

Kingsville, South Texas

Nowhere is the journey through Aztlán more evident than in the works of artists from Kingsville, a small ranching community located in South Texas. This region is known for its farming, but its economic vitality is especially dependent upon the enormous King Ranch, established in 1849 by Richard King. Both Carmen Lomas Garza and Santa Barraza grew up in Kingsville and attended the local university, Texas A&I University[5]. During their years in Kingsville, the artists locked horns with the political and spiritual reality of both the border and the King Ranch.

Although now a resident of San Francisco, much of Carmen Lomas Garza's work is a re-creation of childhood memories from the 1950s and early 60s in Kingsville. The works are called *monitos*, a term that has been defined by Tomás Ybarra-Frausto as "paintings of stylized figures in culturally specific social environments."[6] The flatness of the figures is evocative of *retablo* painting and is reflective of Lomas Garza's interest in the work of modern *santeros*[7], saint painters from Texas and New Mexico. It is, perhaps, this formal association with sacred paintings that gives an air of reverence that seems to surround her visual memories.

In Lomas Garza's narrative work, the viewer is introduced to the history of the region via the personal lens of the artist. Scenes of childhood memories fill in the gaps of a part of Texas history heretofore neglected. It is in this sense that Lomas Garza's work can be understood as subversive: She supplies us with an alternative history, but one based on oral traditions. By doing so, she interrogates and even

negates Western European notions of the primacy of the written word.

In *El Milagro* (1987), Lomas Garza recounts a childhood memory of an apparition of the Virgin Mary, in which Mary appears on the side of a water tank.[8] The young Carmen is shown in a blue dress, yanking her mother forward while religious pilgrims and the just-plain-curious gather around the image. According to the artist, some of the people could not see the apparition but most could. Offerings of flowers are attached to the water tank. At the base of the tank, two young vaqueros display rattlesnakes, while warning the assembled group against going into the cotton fields where they had found the snakes. The rows of cotton in the foreground, the nopal cacti, and the mesquite tree behind the tank reference the South Texas location. Owing to the juxtaposition of snakes and the Virgin Mary in this re-creation, the scene can be understood as a parable about life and death, or about salvation and danger in the small ranching community.

Una Tarde (1993; page 73) depicts an afternoon in the life of young Carmen.[9] An older friend converses with a male suitor through a screen window under the watchful gaze of Carmen's grandmother who is crocheting. For her part, Carmen sits, disinterested on the floor, braiding the fringe of the bed spread. A mother cat with kittens, equally disinterested, stretches out on the floor between the grandmother and Carmen.

While Lomas Garza consistently gives us interesting subjects in her domestic scenes, it is through the details that we derive a sense of time and place. The importance of extended family and generations is invoked not just by the inclusion of Carmen and her grandmother in this painting, but also by the presence of photographs. On the one wall, we see old black and whites, perhaps of the artist's grandparents when they were young. These two watch over the group, while at the same time they symbolically engage in a discourse with the younger generation as represented by the graduation photographs. In this manner, the past, present, and the future are simultaneously acknowledged.

A sense of place is indicated via the branches of mesquite trees in the window and by references to border spirituality. We see the cross above the bed and the image of the Virgin of Guadalupe on an adjacent wall. The shelf before the Virgin supports an offering of roses and a tiny plaster statue of the border healer, Don Pedrito Jaramillo. Don Pedrito was born in the nineteenth century of Tarascan parents in Mexico, but eventually settled on the Los Olmos Ranch in South Texas. Renowned for his ability to cure the toughest afflictions, his status, even during his life, was legendary. After his death in 1908, his grave became a shrine. Letters left daily at the shrine attest to the belief in the continuing powers of the great *curandero*.[10]

Like Carmen Lomas Garza, Santa Barraza grew up surrounded by images of Don Pedrito. A plaster image of the great healer was actually placed in her grandmother's house in close proximity to that of Mary, Joseph, and the Sacred Heart of Jesus.[11] The result was a keen awareness of the importance of border spirituality in South Texas. In Barraza's image of *Don Pedrito* (1991), the personal nature of faith requires the use of a smaller and more intimate format derived from *retablo* painting—the work measures only eight-by-nine inches and is painted on tin. Don Pedrito, seated, is situated against fields of color. For Barraza, color is symbolic; for instance, the blue field references the Rio Grande. According to Barraza, this alludes to the primary element used by the *curandero* in most of his healing ceremonies.[12] The golden field below represents the soil of the valley. The red sky behind him indicates the power and intensity of the healer. Don Pedrito is shown emerging from a maguey plant, the source of all life and healing in the iconography of the artist. That he is born from the soil of South Texas is further underscored by the umbilical cord that joins plant to land. He stares directly out at the viewer, his famous penetrating gaze confronting any potential nonbeliever.

Santa Barraza. *La Lupe-Tejana.* 1995. Oil on canvas, 30 x 50". Collection Olga A. Vasquez

In many of her works, Barraza freely merges pre-Columbian and colonial pasts with contemporary realities. In *La Lupe-Tejana* (1995), the subject of the piece is clearly based on the colonial Virgin of Guadalupe. She is surrounded by ancient indigenous symbols of faith shown in the backyard of Barraza's home, South Texas. In this liminal and magical environment, both *indigenas* and *Nuestra Señora* are born out of life-giving magueys that grow in the vast tracks of land of the Rio Grande Valley. On the left, the distant hills mark the beginning of *el otro lado*, the other side, Mexico.

The brown-skinned Virgin functions as the protectress of the vaqueros. These Mexican and Mexican-American cowboys have for the last one hundred and fifty years worked the King Ranch, an 800,000-acre monument to colonialism and exploitation. To show that this land has been conquered, Barraza inserts the Pre-Columbian symbol of conquest, a hill with an *atl* (spear thrower) dart in the middle ground. Seared into the landscape to the right is the W-shaped brand of the ranch. Closer inspection of La Lupe reveals that this same brand appears as a border design on her mantle. While this might be read as yet another co-optation on the part of King Ranch, it is best understood as a declaration of the ownership of the icon by local Chicanos who work the land and the ranch. The connection between the workers and the icon is further underlined by symbols replacing the stars that traditionally appear on the mantle of Guadalupe. Scattered amid the field of blue, we see the Aztec hieroglyph "Ollin," which indicates movement and change. Joining this symbol are "huelga eagles," the same eagle associated with the struggle of the United Farm Workers. Whether Christian or Pre-Columbian, the symbols used by Barraza are a reflection of spirit and multiple identities that exist in the Aztlán of South Texas.

San Antonio, Texas

The Aztlán negotiated in San Antonio is a combination of urban and fictive space. In this context, *fictive* means the construction of space that caters to tourism. The city, its River Walk, and the Alamo have been marketed so well by the Chamber of Commerce that San Antonio has, to a certain extent, taken on the ambiance of Disneyland. The impact upon the many Chicanos who permanently reside in this city has been ambiguous. Service positions are generally filled with Chicano/a workers, which have led to an economic vitality within the community, but at a "price." The cultural aspects of the community that seem to be valued by visitors are packaged in a manner that often times perpetuate stereotypes. This reductive view of Chicanos/as can only lead to further misunderstandings of contemporary Chicano/a identities.

The ambiguity of the positions occupied by Chicanos/as in San Antonio was not lost on Mel Casas, an artist who has spent the better part of his life living in this city. Although he moved to San Antonio in 1961, he was born and grew up in El Paso. Because El Paso is predominantly Latino, Casas was initially shocked, dismayed, and then fascinated by the attitudes of Chicanos in San Antonio. The colonial presence was palpable to him and he observed that the people acted as though they were being dominated. This proved to be grist for his artistic mill and by the beginning of the 1970s Casas had help to organize Con Safo—a group of Chicano artists dedicated to justice and protest.

Casas's early work is an organic outgrowth of his experiences in the city and reflects his political negotiation of this part of Aztlán. The commentary is serious in that it offers an oftentimes scathing

critique of the status quo. The humor in his work is more ironic in nature. This irony is brought to the fore via contradictions existing between image and text.

An interesting aspect of Casas's work is his formal handling of the canvas. The artist's early compositions can be broken up into three nested rectangular areas. From the outside frame, going toward the center, the first rectangular area consists of a black border. This is generally the place where Casas paints the stenciled script to help explain the image. The second area is blue and acts as a kind of backdrop for figures who are usually engaged in activities in the foreground. The third area, which has been referred to as a "Vista-vision" screen,[13] is reserved for close-ups of icons that help drive home the artist's point. The idea for this third space came from a drive home at dusk.[14] As he was waiting at a light near his home, Casas happened to glance up and see a drive-in screen. There was a close up of the face of a man, then a woman, conversing with each other. The light changed and, as he drove down the street, buildings got in the way and the huge faces seemed to be devouring the silhouettes of the buildings, a spectacle that struck Casas as ironic. Casas believes that movies today give us our notions of morality and that these messages can also sometimes be destructive or subversive. So while Casas can't control what is showing on the screens of his local theater, he can certainly control what he shows on his.

In *Humanscape 63* (1970; page 59), Casas encapsulates the struggle of the 1960s Chicano Art Movement. Dominating the screen in the background is a clear reference to Michelangelo's *Creation of Adam* from the Sistine Ceiling at the Vatican. Within the context of Casas's painting, the meaning of the two hands nearly touching is inherently ambiguous. The most obvious reference is to the creation of the first man, hence all humanity, via the spark of life bestowed by the hand of God. However, the panel from the Sistine Chapel has become an icon in popular culture and therefore also represents Western European notions of "high art." It has come to be understood as a yardstick by which we gauge the art of others. The third hand, shown in silhouette, can be read not only as a gesture of defiance directed toward traditional constructions of art and the art establishment, but also as a rallying point for the audience. If we read the Sistine reference as part of a movie-house screen, then the ghostly gesture actually seems to come from an anonymous audience member.

Supporting the message of the central hand are emblems of an alternative history, the struggles of the 1960s. From left to right, a black anarchist flag[15] is a backdrop for a maraca-wielding hand, a reference to Chicano indigenous roots, and a fist raised in solidarity. At center, four hands spell out L-O-V-E in sign language, which references the peace movement. In front of the flag of the United Farm Workers is a hand holding a reefer and another in the sign of "O.K." The "show of hands," then, represents multiple voices involved in actively changing an urban space heretofore defined by the dominant culture and its art.

In another early image by Mel Casas, *Humanscape 68* (1973; page 60), the artist offers an homage to domestic relations. A two-dimensional brown-skin maid is surrounded by the three-dimensional household members. Because Casas draws on flat comic-book characters in his representation of the maid, she becomes less real than those who employ her or even their pets. She has been repackaged in nonthreatening Pop Art format—the speech-balloon provides us with her automaton responses and underlines her transformation into a mechanized stereotype. She becomes one of many other mechanical conveniences in this house. The curtain, which has been drawn back, suggests domesticity, but it also symbolizes the theatrical nature of this human drama.

In *Humanscape 62* (1970; page 58), Casas presents us with a field of giant brownies—the quintessential American junk food—in front of which is placed a selection of people who have been stereotyped as "brownies." The central icon around which all others pivot is that of the Frito Bandito, who rides

atop the back of a pre-Columbian *calavera*. Both of these cultural icons are cast in the same green hue as the double-headed Aztec turquoise serpent that seems to emanate from them. The trio—skeleton, Bandito, and serpent—have in common the use of green paint and that they are not of this world. Verisimilitude is reserved for the figures of the Navajo, on the left, shown with lids closed, the young girl in the brownie uniform, and the old women who seem lost in conversation in the right middle ground. The latter grouping is based early twentieth century representations by the Mexican painter, Siqueiros. Like the plate of brownies, the humans flanking the central stereotype are presented to the public for consumption. In these three works, the implication is that the "dominant class in Texas profits from a culture of poverty."[16] This is done in a number of ways: By asserting the superiority of western culture, via the actual exploitation of the labor of others, or by the consumption of stereotypes. The role of the artist here is to remind the public of the presence and the irony of injustice.

Although César Martínez has also lived many years in San Antonio, he still considers himself to be from the border town of Laredo, where he was born. He attended Texas A&I, overlapping with the artists Carmen Lomas Garza and Santa Barraza. Starting off his college career as a business administration major, he quickly realized that his talents lay in art. After graduating in 1968, he was drafted into the military, where he spent the next four years. In the early 1970s, he returned to Texas and eventually settled in San Antonio where he joined Con Safo. Creative differences became evident in the group and Martínez eventually formed Los Quemados ("the burned ones") with other artists, including Carmen Lomas Garza.[17]

Like Mel Casas, Martínez explores popular culture in San Antonio. He is particularly well known for his Pachuco Series in which he presents a series of *pachucos* or *batos,* tough street guys. In part, Martínez's representations can be understood as a reaction against the hyper-stylized *pachuco* that he saw coming out of Hollywood during the 1970s in films such as *Zoot Suit.*[18] He handles the character development for his *pachucos* in much the same manner as a writer develops a character in a story. Martínez begins by drawing from personal experience—he studies old photos from his high school yearbook and he even tracks down old photos published in obituaries from the local paper.[19] Eventually, a composite character emerges—familiar but anonymous. The resulting, sometimes-flawed, humanness revealed in these representations, displayed in works such as *El Guero* (1987) or *Bato con Sunglasses* (2000; pages 103 and 102), barely skirts caricature with all its complexities. In this series, *Hombre que le Gustan las Mujeres* (2000; page 107) is perhaps one of the best examples of human complexities and conceptual tension brought to the fore. Here, Martínez presents us with a "lady's man" who has clearly seen better days. Martínez also makes certain that the viewer doesn't read into this image the stereotypical Latin Lover. So while the man negates any of the traditional stereotypes, he actively engages in the perpetuation of stereotypes of the women whom he likes. We see the Virgin mediating between two extremes—a hyper-sexualized defiant nude on the one arm and a demure señorita on the other. Despite his comical and ironic aspects, however, the frankness displayed in the character's gaze forces us to realize that what we view is part of the human condition. And in this recognition, we feel compassion and affection for this individual.

Perhaps as intriguing as Martínez's characters is his treatment of the overall composition. The individuals are often off-center, seen, for example, in *El Guero*, and they are always placed against backgrounds of intense color and surface agitation. For this, Martínez is particularly indebted to the Abstract Expressionist artists Gene Davis, Kenneth Noland, and Mark Rothko, and to their development of color-field painting. In their works, the canvases are broken up into fields of color and texture enlivens the surface. Martínez takes this a step further by creating a compositional balance between the subject and

his environment. In some instances, this play of foreground and background is so intense that the artist has come to view the Pachuco Series as abstract paintings that happen to use figuration.[20]

Casas and Martínez are at ease with the inherent ambiguities of cultural and geographic borders that characterize today's Aztlán. Both artists freely manipulate popular culture and well-known artistic styles and iconography in a manner that introduces the viewer to their unique perspectives. Casas presents us with a collection of familiar figures derived from advertising, high art, and popular culture in order to comment upon stereotypes and injustice. Martínez takes the *pachuco* of his childhood and elevates him to the status of an icon. He then combines this antihero of the barrio with his formal interests in Abstract Expressionism. And why not? All of these are a natural part of the border experience and the negotiation of dual identities. As Mel Casas has said, "When you are from the border, it's pesos to dollars, dollars to pesos, kilos to pounds, and pounds to kilos. You use whatever language is available to negotiate the space and to get the deal done."[21]

Two other artists who also derive their inspiration from San Antonio are Adan Hernández and Marta Sánchez. Both depict the west side of San Antonio but in different ways. Hernández's urban paintings have a distinctive dark blue palette, which the artist feels more accurately reflects feelings of alienation and loss.[22] Most of his images are set at night and depict a city full of beauty and turmoil. These works have been described as Chicano-noir[23] and often depict forties-style gangster-types engaged in violent acts. In *Drive-by Asesino* (1992; page 91), for example, we see an anonymous killer firing his gun from the back of a speeding automobile. The blast of the gun is reflected in the buglike lenses of his sunglasses. This, along with the fact that his raised arm covers his mouth, lends an alien air to the protagonist. Unlike Martínez's very human *pachuco,* Hernández's gangster is presented as part of a killing machine; his arm, seemingly emanating from his mouth, forms a deadly proboscis that speaks for the otherwise mute killer. His clothing and body derive their light (and are therefore defined) by the explosion of his revolver. The dialogue that was present between the viewer and the subject in Martínez's paintings is less pronounced here. Hernández clearly views his *asesino* as part of a much larger narrative. It is a narrative reflected in the body of the speeding car and one that includes the city as well as a terrified man who presumably responds to the blast by running after yet another racing vehicle. The "dialogue" exists primarily between actors separated by a couple of traffic lanes. We viewers are left to witness the event, but are helpless to respond to it.

In *La Bomba* from 1992 (page 90), we see a much more ambiguous protagonist and narrative. Here, Hernández freezes the frame the instant a bomb detonates high above the city. The main character reels from the blast's impact and crashes though a window falling into the breezeway that separates the buildings. He protects his face with a raised hand while his fedora and a shoe are literally torn off his body by the violence of the explosion. Yet, we are not quite sure of cause or effect. Was the man responsible for the bomb? Was he disarming it? Or, was he merely an innocent bystander? Will he fall to his death? Or will his fall miraculously be broken before he reaches the pavement below? This particular character often appears in Hernández's paintings and is based on the artist's dreams of a *pachuco.* The artist later thought up a series of scenarios in which this unlikely hero participates. However, the details and aftermath of these episodes are only completed through the viewer's imagination.

The odd perspective evident in *La Bomba* and other paintings from the early 1990s, is largely due to the fact that Hernández lived on the seventh floor of an old apartment building during this time. From his vantage point, not only could he survey the nightlife in the streets below, but he could also view other activities occurring in buildings across the breezeway. In *Sin Titulo II* (1988; page 88), we are introduced

to the city via the perspective of the artist. We see a young woman in a nightgown, cigarette in hand, watching television. Below her, crazily swaying palm trees take on a life of their own. Because of the way her window frames her apartment, it is as though we are watching our own television—we are both distanced from the unknowing subject as well as invited to observe her further. Even so, the overall sense derived from the scene is one of ambiguous power. While the voyeur takes charge of that which is viewed, he is likewise powerless to connect with the young woman or to change the moving city below. In the context given to us by the artist, the viewer has no choice but to merge with this environment and to become part of a larger mindless and threatening machine.

Marta Sánchez's very different view of the same west side is one that is distanced by time and geography. Although her family continues to live in San Antonio, Sánchez herself now lives in Philadelphia. Her Train Series is based on memories of the train yard across from her parents' house, which fascinated her and which as a child she frequently drew.[24] For Sánchez, trains were a personal connection to her grandparents. During the first half of the twentieth century, Mexican circuses were transported by train. Her grandfather had been a lion tamer for one such circus that traveled from town to town around South Texas. Eventually, he met her grandmother and the family settled in San Antonio.

Marta Sánchez. *Train Yard/Series 1.* **1997. Oil on metal, 36³⁄₄ x 36³⁄₄". Collection the artist**

In *Train Yard/Series 1*, the simplicity of childhood remembrance is brought to life chiefly by the use of primary colors that have been applied to different zones. A blue rain-drenched sky defines the upper third of the painting while the lower two-thirds are defined by golden earth, here and there touched by the memory of rain. Both sky and earth seemingly give life to the red train in the center of the canvas. Indeed, the entire yard appears alive after the storm as machines and tracks seem anxious to be on their way. To the left, one twisted section of old track appears to want to piggyback a more direct line leading out of the yard. Both tracks and machines move toward a horizon that is marked by distant bridges and by the moving storm.

Childhood stories of family origins and imagined journeys are converged by Sánchez's pictorial handling of space in *Train Yard/Series 4*. The multiple-canvas format draws its inspiration from church polypychs, multi-paneled altarpieces. The telephone lines crossing the upper regions of the canvas at crazy angles surely reference the irregular leading in stained glass windows. At the same, time they also underscore the fragmentation of memory, which is part of any narrative.

Hernández and Sánchez offer us two very different views of the city. Whereas Hernández explores the complexities of a single instant in time, Sánchez captures a bit of the past and presents it to us via the lens of memory. At the same time, because the subject of her work is trains, a destination and a future are also implied. We are invited to use our imaginations and to follow the trains off the canvas— and travel with them as they journey across the distances that separate towns.

West Texas

The final pair of artists, Tina Fuentes and Gaspar Enríquez, is part of the vast area of Aztlán known as West Texas. Here, the sense of land is acute. Whether traveling across the plains that define the area surrounding Lubbock or negotiating the moonscape outside of El Paso, what these places have in common is a vastness that is marked by an endless repetition of geological forms. This is brought home by the fact that the area around Lubbock is known as the *LLano Estacado*, the "staked plains." It was given this name by

the *conquistatores* who, after traversing the monotonous landscape for several weeks, found themselves traveling in circles. To compensate for the lack of natural landmarks, like Hansel and Gretel, they began to leave their own kind of breadcrumbs in the form of stakes, which they hammered into the ground.

In West Texas, fields of tumbleweed are interrupted by the occasional rock outcrop. More dramatic departures in the terrestrial monotony come via atmospheric phenomena, such as when the line between earth and sky is frequently blurred by dust storms or tornadoes. Tina Fuentes, an artist and professor at Texas Tech University in Lubbock, takes her inspiration from such atmospheric collisions. She is intrigued by the forces of nature and by man's position in the overall scheme of nature. In *Raso Negro* (1987), Fuentes explores the violence of a rogue tornado. In depictions such as these, the artist often references the transient relationship of humans to the land. This is done by inserting a figure into the painted field only to obliterate it through a series of paint layers or surface abrasions. The pentimento is barely decipherable in such works.

In another work, *Cielo de oro #2*, Fuentes is much more direct with her references to nature. Here,
the artist pays homage to the oh-so-rare rock outcrop. Summer's familiar golden sky finds its companion mirrored in the ochre and yellow shades of the stone. Clouds and shadows on the land are reduced to undulating strips of color that float across the surface of the canvas, clearly a reference to the oceanlike quality of the Southern Plains. At the same time, this dynamic use of color also attests to Fuentes's ability to provide a visual solution for her landscapes in Abstract Expressionism.

Like Fuentes, Gaspar Enríquez is a native West Texan. He is a high school teacher in El Paso's "segundo barrio," located downtown.

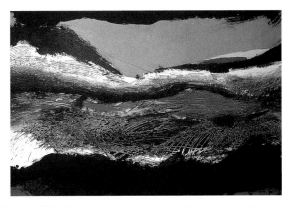

Tina Fuentes. *Cielo de Oro*. 1988. Mixed media on paper, 42 x 30". Collection Texas Tech University Libraries, Lubbock

Also like Fuentes, he pays tribute to the environment. *Tirando Rollo* (1999; page 63) is fairly representative of Enríquez's style. The figure, in this case one of Enríquez's students, floats in a space that lacks definition. In this three-paneled work, the subject is just under life-size and the ease with which the artist manipulates large figures is reflective of years of mural production.

The hand gestures made by the young woman are called "signings" and have to do with a local phenomenon. El Paso has a county jail located downtown and young women used to line up on the two streets facing the building and "sign" messages to their incarcerated loved ones. A kind of "cottage industry" was set up when women who were particularly adept at signings, such as Enríquez's student, would hire themselves out to other women who had boyfriends or husbands in jail but not enough time or the means to get down to the jail. After several years, however, someone complained to the sheriff's office about the young women and suggested that what they were actually doing was making drug deals. Reflective film was quickly put up on the windows and communication between inmates and wives and girlfriends ceased. This was one year prior to the creation of this work.

In Enríquez's art, we see how the notion of lived experience and circumstance interacts with landmarks such as the county jail. But how does the artist address the issue of environment? In many of his paintings, the artist situates his subjects in a similar void of tan space. This space actually seems to bring together two seemingly contradictory aspects of El Paso: First, it can be read as a reference to the urban environment, as the color suggests the pavement that connects all parts of the city. But the tan void also may allude to the vast desert surrounding El Paso. As humans traverse this immense and sparsely vegetated landscape, it is as though they float freely through a huge tan space. Placed against Enríquez's

uninflected background, the subject is situated in time only by means of personal dress and actions. The land itself remains immutable in its nature.

These artists from Aztlán share an extraordinary sense of this land. At the same time, they are acutely aware that the topography through which they travel goes far beyond any simple geographic designation or shared set of experiences. Some of the artists explore life in large cities and comment upon urban plights such as racism and violence. By critiquing these realities, their works go beyond the aesthetic—they reaffirm and give voice to those who share such experiences while conveying an alternative reality to those who do not share these experiences. For other artists working on the Third Coast, Aztlán can provide a stage on which to play out and explore memories born of family histories and legend. Spirituality, politics, and a basic exploration of human nature are all given context by an overarching sense of land, space, and time.

Bibliography

Corpus Christi Caller Times. Monday, Dec. 22, 1997. Interactive webpage: www.caller.com/newsearch/news10144.html

Grant, Mary Lee. "Don Pedrito still attracting visitors after almost 90 years. *"Corpus Christi Caller Times.* Monday, Dec. 22, 1997. Interactive web page: *www.caller.com/newsearch/news10144.html*

Hernández, Adan. Artist web page, http://members.aol.com/Adanarte.html.

Herrera-Sobek, María, ed. *Santa Barraza, Artist of the Borderlands.* College Station: Texas A&M Press, 2001.

Laguna Gloria Art Museum. *Mel Casas.* (introduction by Dave Hickey). Austin, Tex.: Laguna Gloria Art Museum, 1988.

Leal, Luis. "In Search of Aztlán" in *Aztlán: Essays on the Chicano Homeland,* ed. Rudolfo A. Anaya and Francisco A. Lomelí. Albuquerque, N.M.: University of New Mexico Press, 1989.

Lomas Garza, Carmen. *In My Family/En mi familia.* (Paintings and Stories by Carmen Lomas Garza as told to Harriet Rohmer). San Francisco: Children's Book Press, 1996.

Quirarte, Jacinto and Carey Clements Rote. *César A. Martínez: A Retrospective.* San Antonio, Tex.: The Marion Koogler McNay Art Museum, 1999.

Ybarra-Frausto, Tomás and Terecita Romo. *Carmen Lomas Garza: Lo Real Maravilloso (The Marvelous/The Real).* San Francisco: The Mexican Museum, 1987.

Notes

1. Special thanks to the artists who took the time to speak to me regarding their works and to my colleagues, Patricia Reilley and Andrea Pappas, who listened to and critiqued an early version of this article.
2. In 1968, the poet Alurista mentioned the concept of Aztlán to his class at San Diego State University; a year later, Rodolfo 'Corky' Gonzáles introduced it to the general public at Chicano National Liberation Youth Conference held in Denver, Colorado. Leal, 11.
3. Leal, 8.
4. ibid.
5. This is now Texas A&M University, Kingsville.
6. Ybarra-Frausto, 7.
7. ibid, 9.
8. Lomas Garza, n.p.
9. ibid.
10. A *curandero/a* is a medicinal practitioner who uses a combination of spirituality and herbs to cure patients. See Grant, Dec. 22, 1997.
11. Herrera-Sobek, 28.
12. ibid., 13.
13. Hickey, in *Mel Casas,* 6.
14. Casas, telephone interview with author, May 24, 2001.
15. According to Casas, the flag represents extreme measures, but they are measures which are taken out of necessity. Casas, telephone interview with author, May 24, 2001.
16. Casas, telephone interview with author, May 24, 2001.
17. Quirarte, 22.
18. Martínez, interview with author, May 25, 2001.
19. ibid.
20. Martínez, interview with author, May 25, 2001.
21. Casas, interview with author, May 24, 2001.
22. Hernández, interview with author, May 24, 2001.
23. *http://members.aol.com/Adanarte.html*
24. letter to author from Sánchez, March 17, 2001.

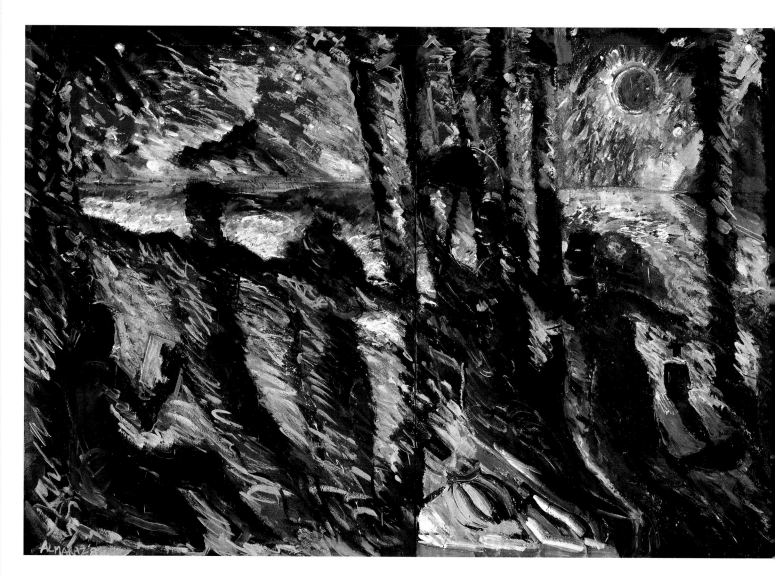

Carlos Almaraz. *Early Hawaiians*
(triptych). 1983. Oil on canvas, 163 x
72" overall. Collection Los Angeles
County Museum of Art. Gift of
William H. Bigelow, III. M.91.288 a-c.
© 2002 The Carlos Almaraz Estate

*Almaraz's virtuoso ability to put paint on canvas is like listening to
John Coltrane or any other great jazz player.*

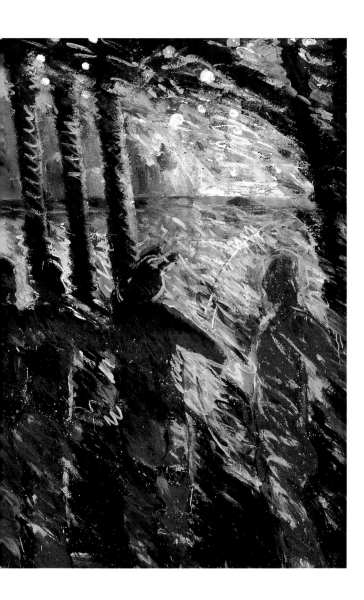

Almaraz wanted to get a feel for the thickness and texture of the paint, so he approached the painting as though it were a piece of sculpture.

Carlos Almaraz. *Creatures of the Earth*. **1984. Oil on canvas, 35 x 43".
Collection Cheech and Patti Marin**

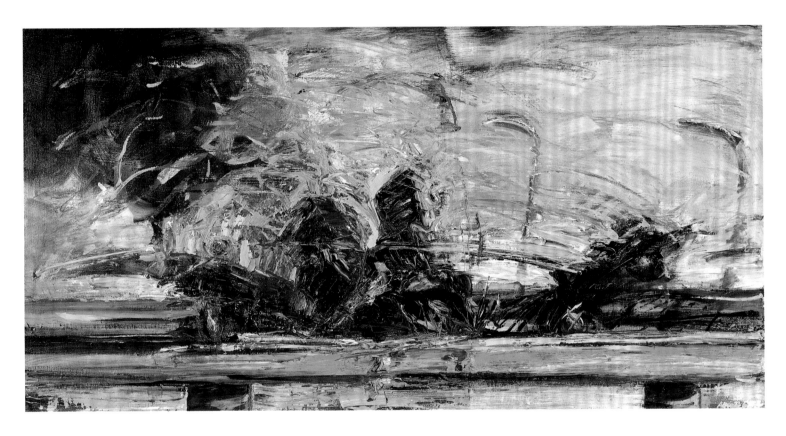

Carlos Almaraz. *Flipover*. 1983.
Oil on canvas, 72 x 36". Collection
Mrs. Liz Michaels Hearne and John
Hearne

Carlos Almaraz. *Sunset Crash*. 1982.
Oil on canvas, 43 x 35". Collection
Cheech and Patti Marin

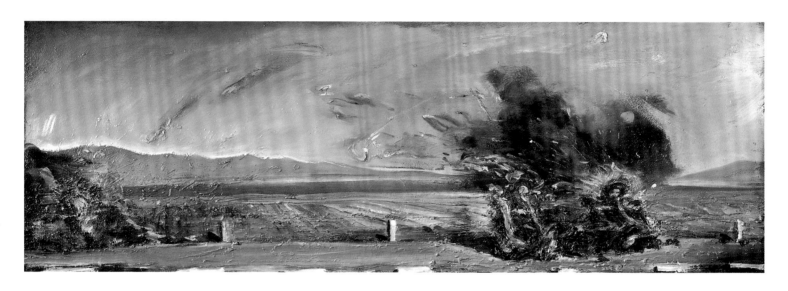

Carlos Almaraz. *West Coast Crash*.
1982. Oil on canvas, 54 x 18".
Collection Elsa Flores Almaraz

West Coast Crash, detail

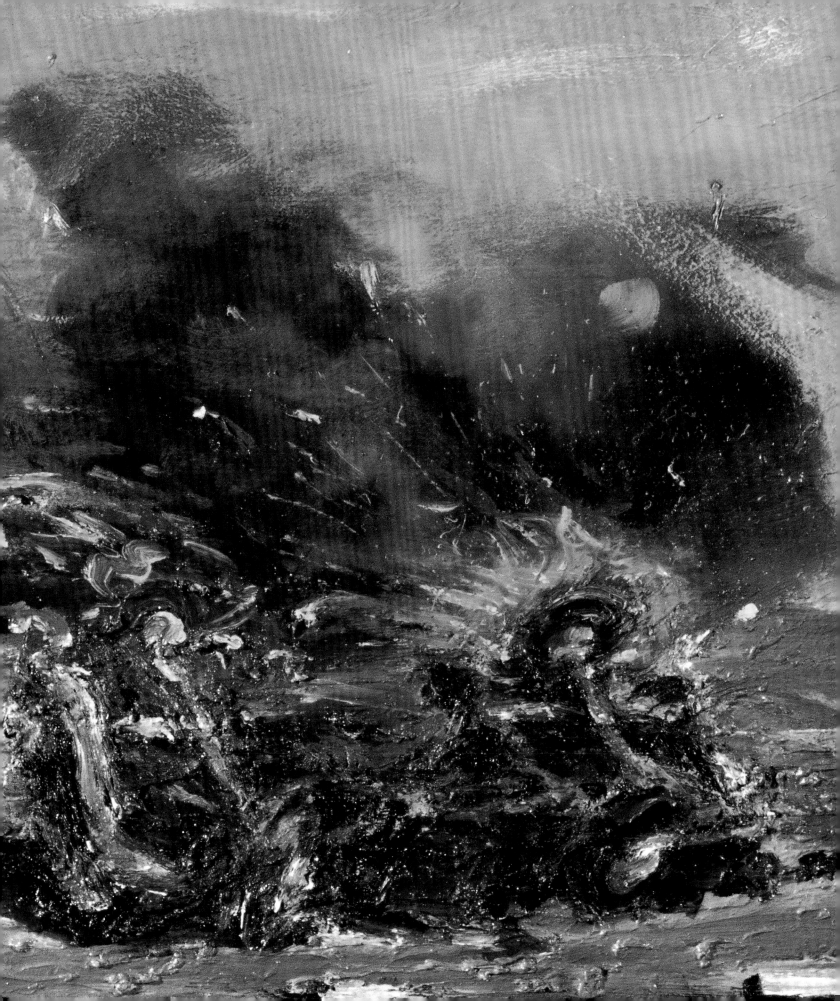

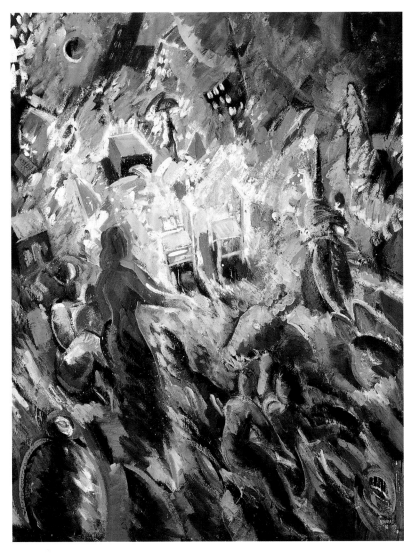

Carlos Almaraz. *The Two Chairs*.
1986. Oil on canvas, 66 x 79½".
Collection Cheech and Patti Marin

The meaning of this painting always puzzled me until a friend told me of the saying, "You can't sit on two chairs at the same time."

Carlos Almaraz. *Pyramids* (triptych).
1984. Oil on canvas, 144 x 96" overall.
Collection Cheech and Patti Marin

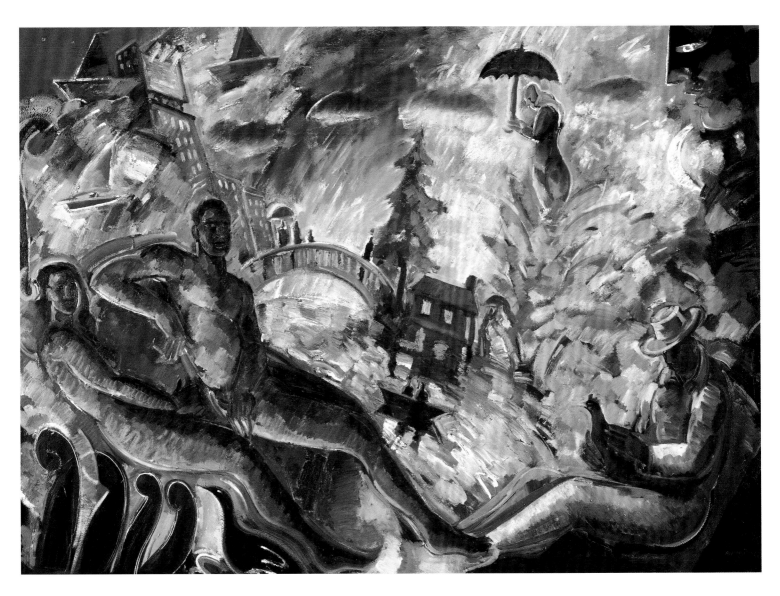

Carlos Almaraz. *California Natives*.
1988. Oil on canvas, 84 x 60".
Collection Cheech and Patti Marin

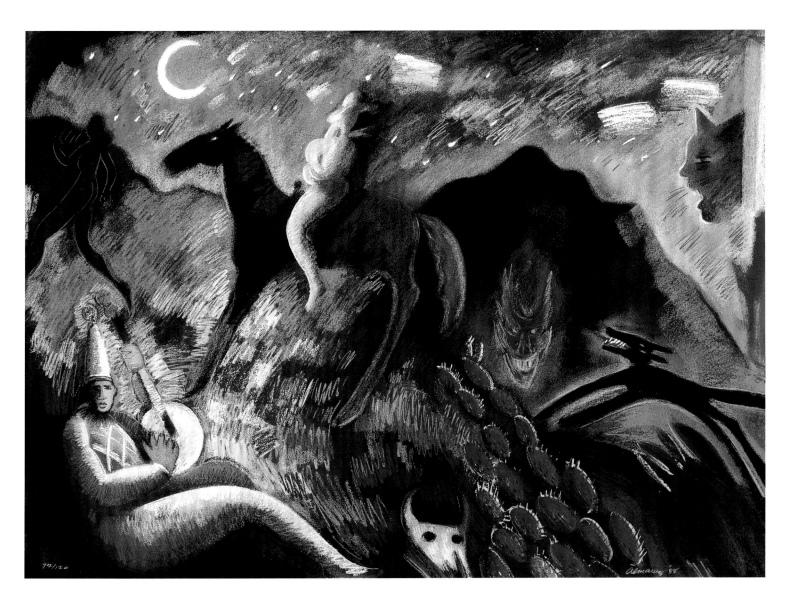

Carlos Almaraz. *Southwest Song.*
1988. Serigraph, 48 x 34½".
Collection Cheech and Patti Marin

Chaz Bojórquez. *Words That Cut.*
1991. Acrylic on canvas, 92 x 65".
Collection Nicolas Cage

Chaz Bojórquez. *Chino Latino*. 2000.
Acrylic on canvas, 72 x 60".
Collection Cheech and Patti Marin

Bojórquez advances graffiti art with the introduction of calligraphy, which he studied extensively.

David Botello. *Wedding Photos—Hollenbeck Park*. 1990. Oil on canvas, 47½ x 35¼". Collection Cheech and Patti Marin

Botello is the colorist for the East Los Streetscrapers, a mural and pubic works group that is responsible for some of the most famous murals in East L.A. and other parts of the country. Both this painting and the one opposite equally depict the celebratory and shadowy aspects of one of the best-known parks in East L.A.

David Botello. *Alone and Together
Under the Freeway.* 1992. Acrylic
on canvas, 34 x 25". Collection
Cheech and Patti Marin

BROWNIES OF THE SOUTHWEST

Mel Casas. *Humanscape 62
(Brownies of the Southwest).* 1970.
Oil on canvas, 97 x 73". Collection
the artist

SHOW OF HANDS

Mel Casas. *Humanscape 63 (Show of Hands)*. 1970. Oil on canvas, 97 x 73". Collection the artist

This painting has always cracked me up: the blatant meaning of the finger is ironically contrasted with the subtlety of being rendered as a silhouette. Chicanos have always demonstrated a sense of humor in the face of adversity.

Mel Casas. *Humanscape 68 (Kitchen Spanish)*. 1973. Oil on canvas, 97 x 73". Collection the artist

Artist's statement: Communication has been a pursuit of all humans since the beginning of time. Like people of every culture, Mexican-Americans—in particular those in west Texas and East Los Angeles—developed a form of communication marked by creativity and diligence. They call it *"Tirando Rollo,"* an expression that originated in Calo, a language adopted by el Pachucismo in the 1940s. As communication, *Tirando Rollo* takes various forms: telling a story, chatting aimlessly, or speaking earnestly with a friend. An especially remarkable form of *Tirando Rollo* can be spotted daily in El Paso, Texas, a border community directly across the Rio Grande River from Mexico. There, along the perimeter of the county jail, wives, girlfriends, relatives, and friends of the inmates gather on the sidewalks and gaze at the narrow windows of the jail. Unable to connect through traditional means, visitor and inmate alike transcend their separateness and communicate through elaborate arm gestures, proving once again that heartfelt communication can never be denied.

Gaspar Enríquez. *Tirando Rollo (I Love You)* (triptych). 1999. Acrylic on paper, 81 x 58" overall. Collection Cheech and Patti Marin

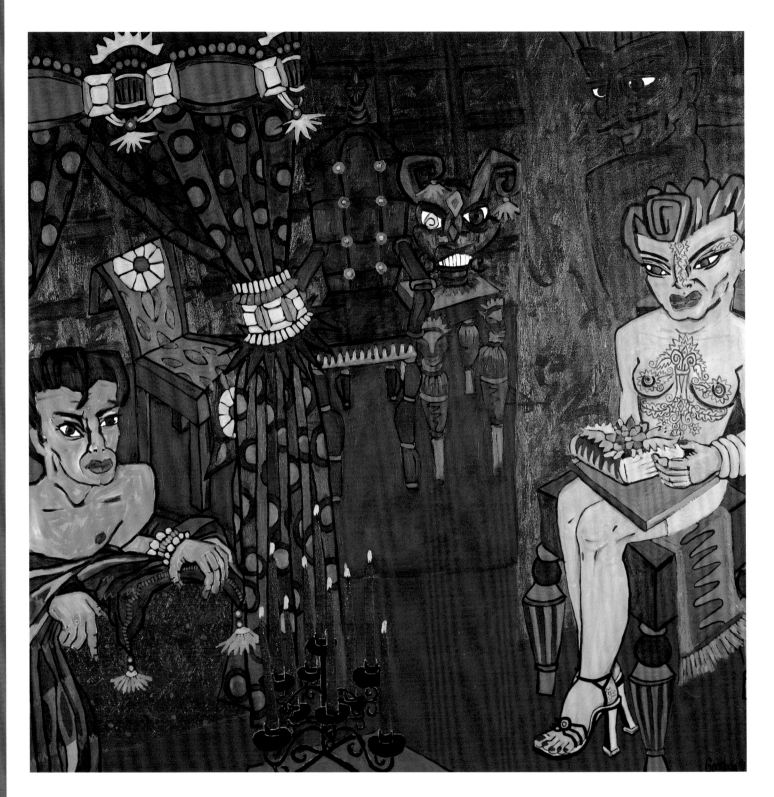

Diane Gamboa. *Tame a Wild Beast.*
1991. Oil on canvas, 54 x 54".
Collection the artist

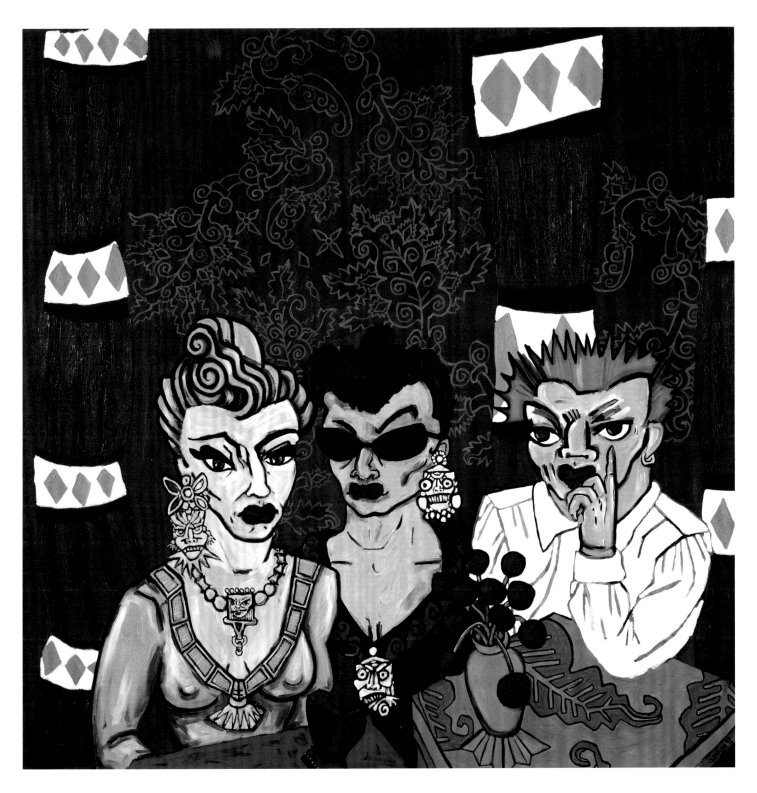

Diane Gamboa. *Time in Question*.
1991. Oil on canvas, 54 x 54".
Collection the artist

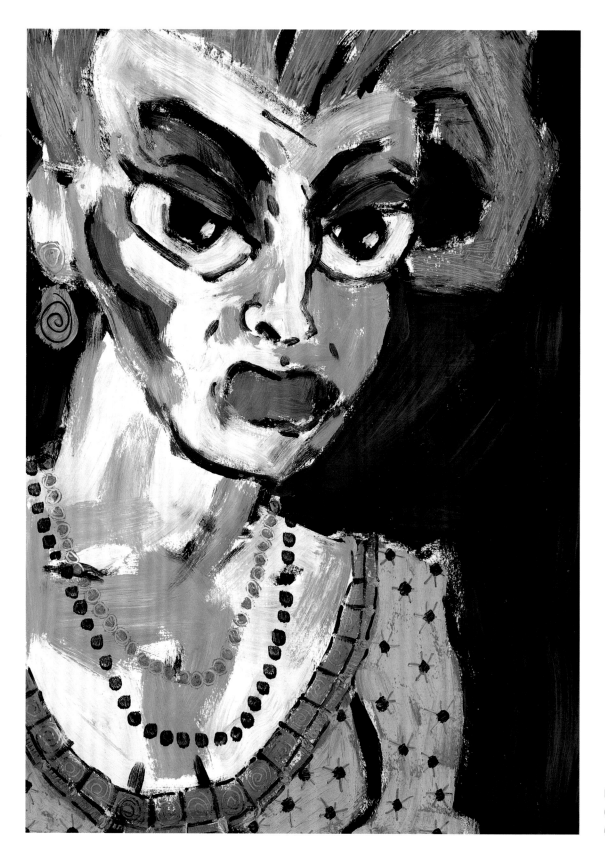

Diane Gamboa. *Green Hair*. 1989.
Oil on paper, 18 x 25". Collection
Cheech and Patti Marin

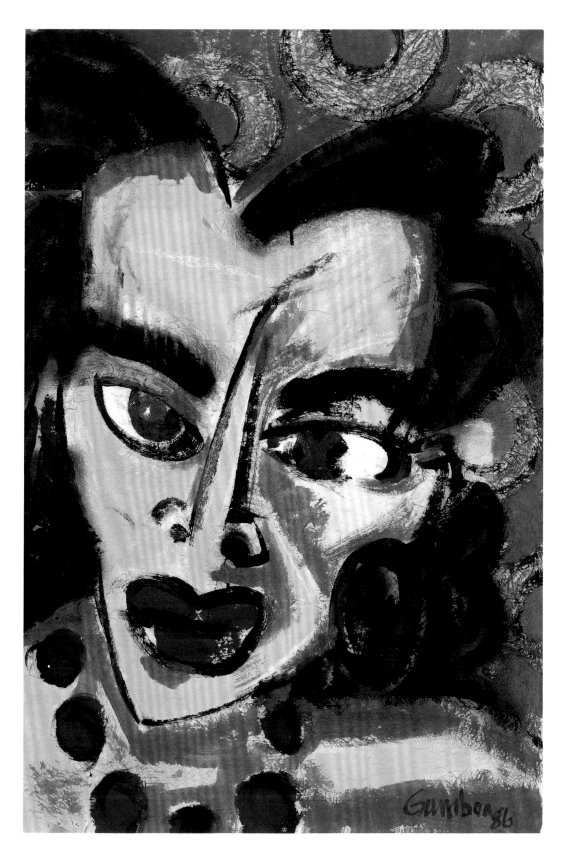

Diane Gamboa. *She Never Says Hello*. 1986. Mixed media on paper, 24 x 36". Collection Cheech and Patti Marin

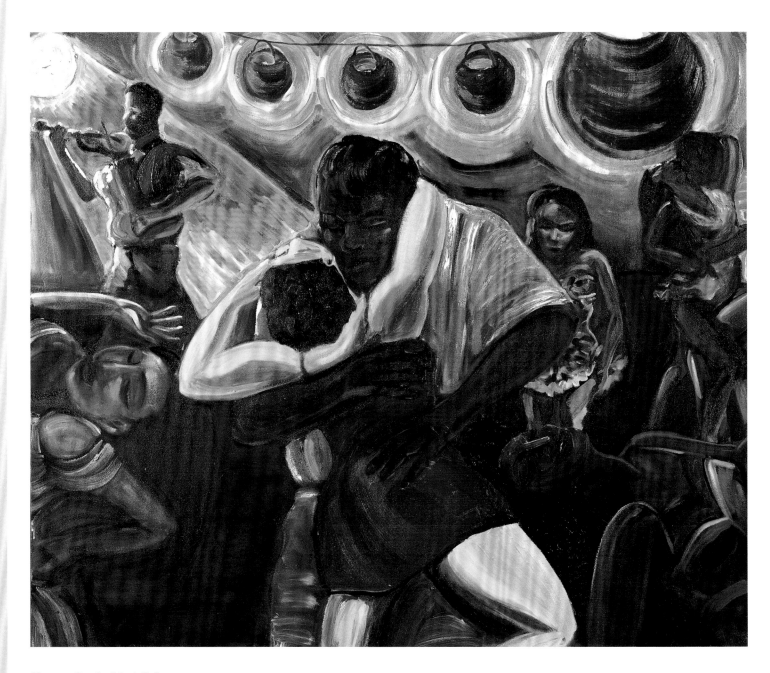

Margaret García. *Eziquiel's Party.*
2000. Oil on canvas, 54¼ x 44¾".
Collection Cheech and Patti Marin

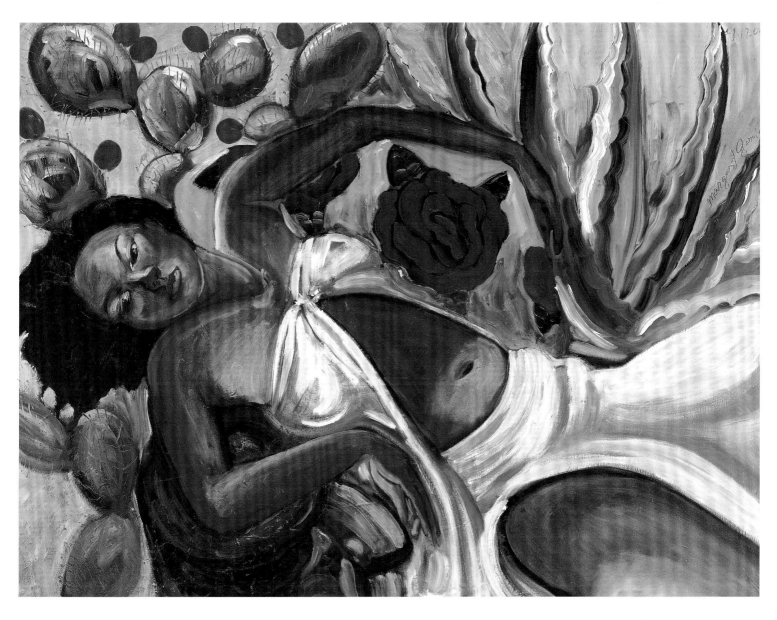

Margaret García. *Janine at 39, Mother of Twins*. 2000. Oil on canvas, 47½ x 35½". Collection Cheech and Patti Marin

If there is a visual definition of the lushness, the strength, and the beauty of women, this painting is it.

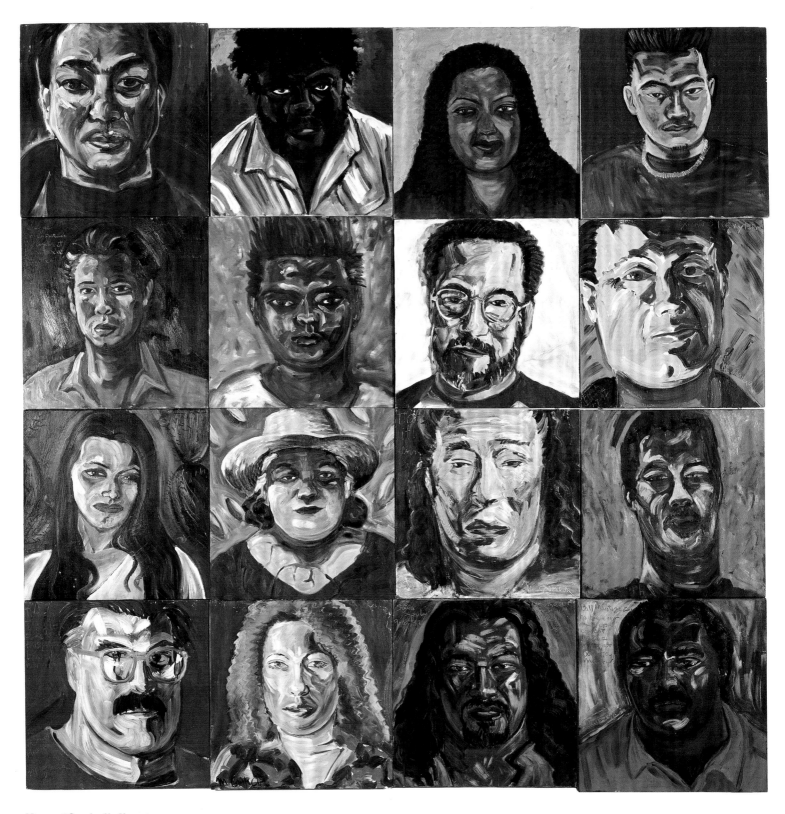

Margaret García. *Un Nuevo
Mestizaje Series* (The New Mix).
(16 works). 1987–2001. Oil on
canvas, oil on wood, 96 x 96"
overall. Collection the artist

Un Nuevo Mestizaje Series
(The New Mix), detail

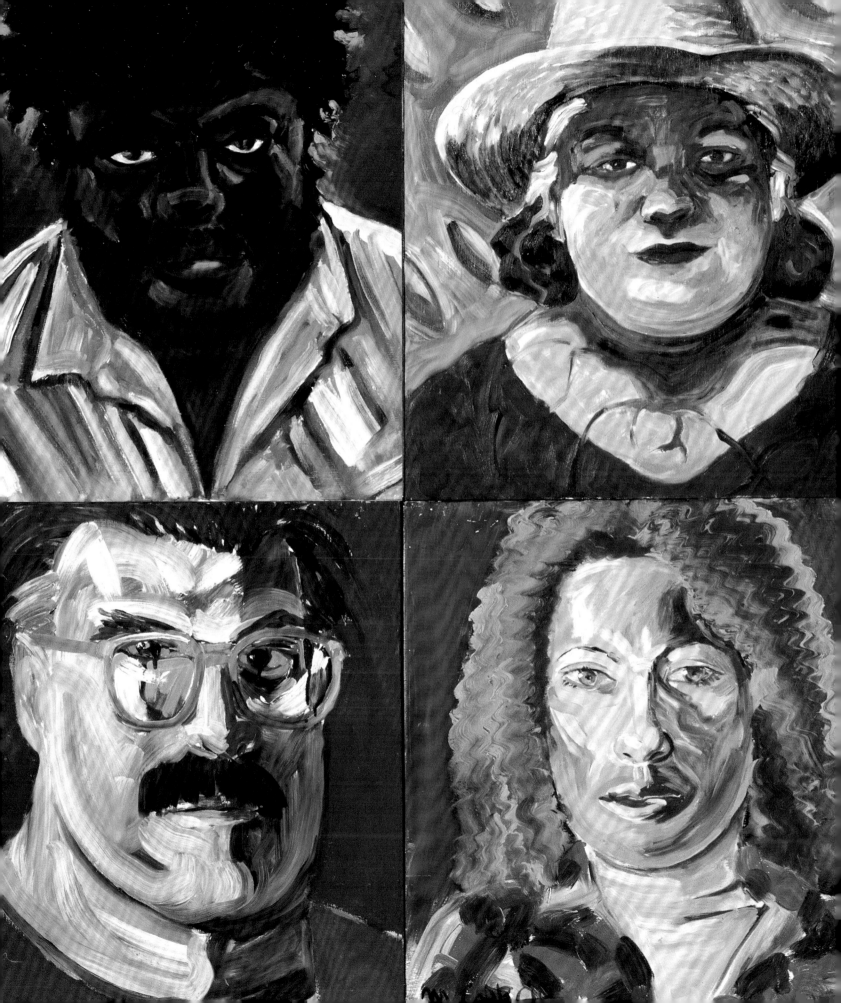

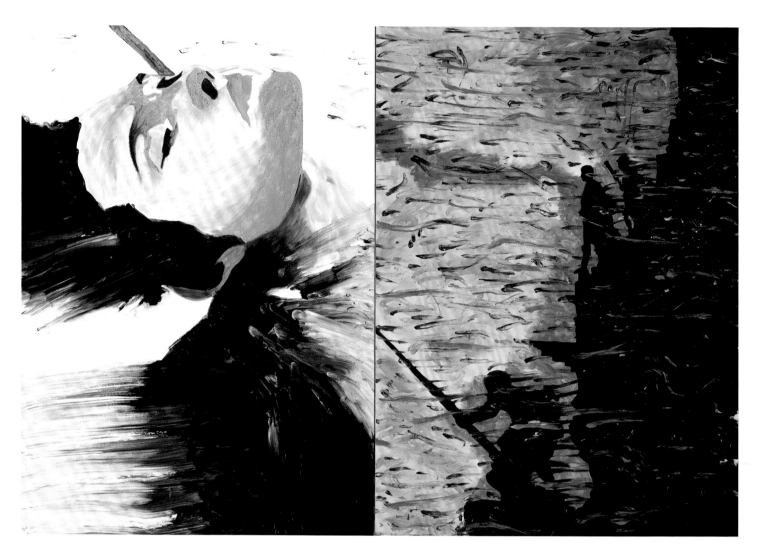

Rupert García. *Homenaje A Tania y
The Soviet Defeat* (Homage to Tania
and the Soviet Defeat) (diptych).
1987. Oil on linen, 101 x 69" overall.
Collection the artist

Rupert García. *La Virgen de Guadalupe & Other Baggage*. 1996. Pastel on three sheets of museum board, 31½ x 40" each. Collection the artist. Courtesy the artist and the Rena Bransten Gallery, San Francisco, and Galerie Claude Samuel, Paris

Carmen Lomas Garza. *Heaven and
Hell II*. 1991. Oil and alkyd on
canvas, 48 x 36". Collection the artist

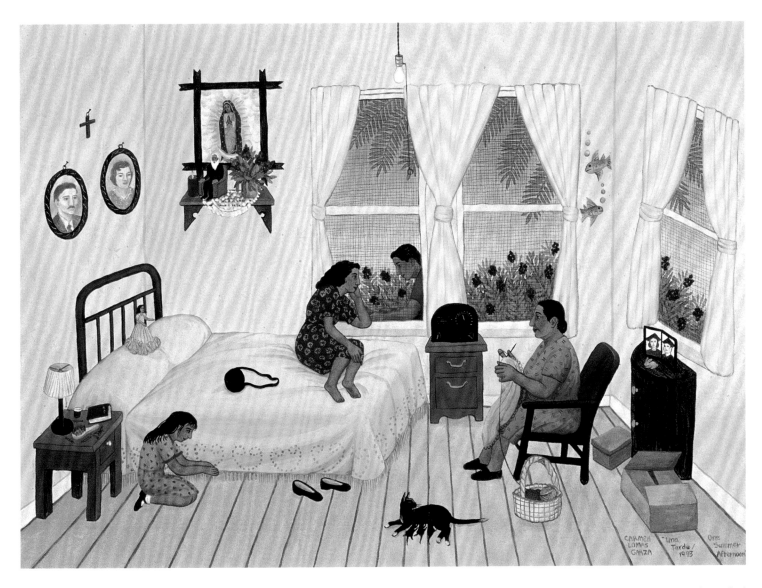

Carmen Lomas Garza. *Una Tarde/
One Summer Afternoon*. 1993. Alkyd
on canvas, 32 x 24". Collection the
artist

*Simplicity and complexity at the same time. You can almost feel
the heat of the afternoon breeze.*

Carmen Lomas Garza. *Quinceañera*
(The Fifteenth Birthday). 2001.
Oil and alkyd on linen on wood,
48 x 36". Collection the artist

*In Mexican families, when a girl reaches the age of fifteen
(quince), she is presented to society as a woman. Other than
her wedding, this coming-of-age party is probably the biggest
traditional ceremonial event that she will ever experience.*

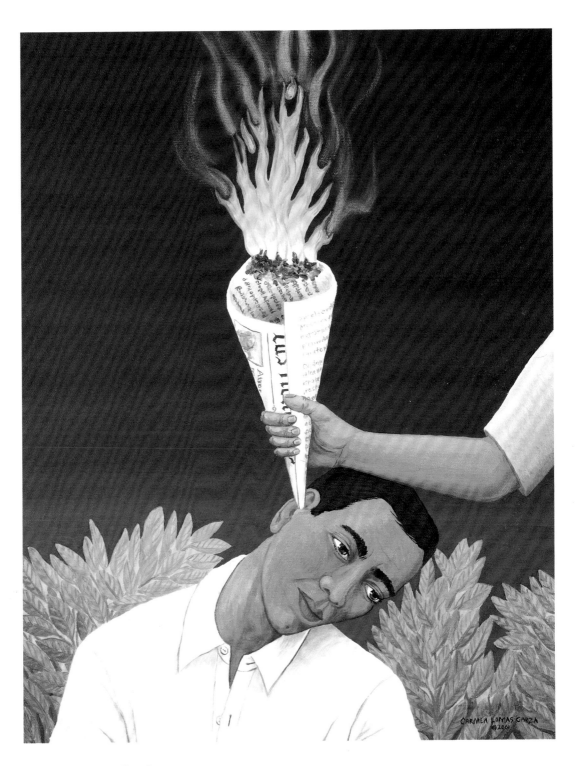

Carmen Lomas Garza. *Earache Treatment Closeup*. 2001. Oil and alkyd on canvas, 14 x 18". Collection the artist

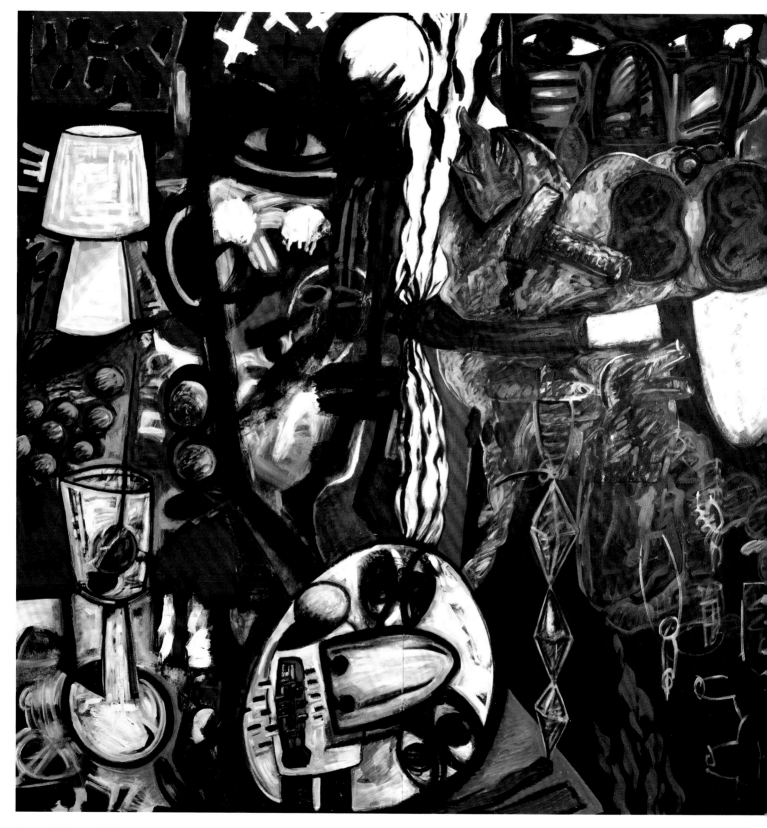

Gronk. *La Tormenta Returns*
(triptych). 1998. Acrylic and oil on
wood, 144 x 96" overall. Collection
Cheech and Patti Marin

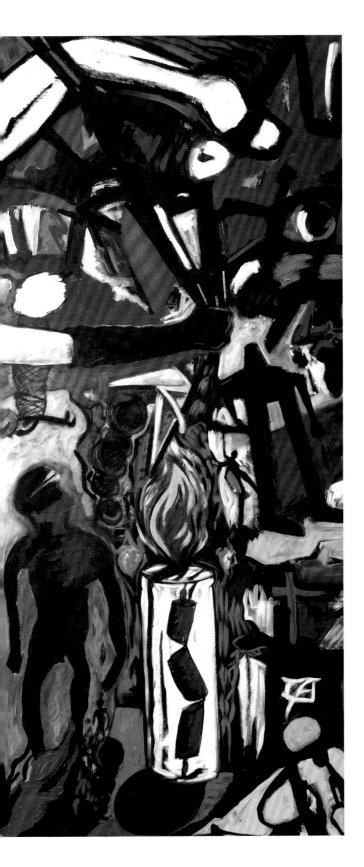

Painted live in front of an audience in San Francisco accompanied by the Kronos Quartet.

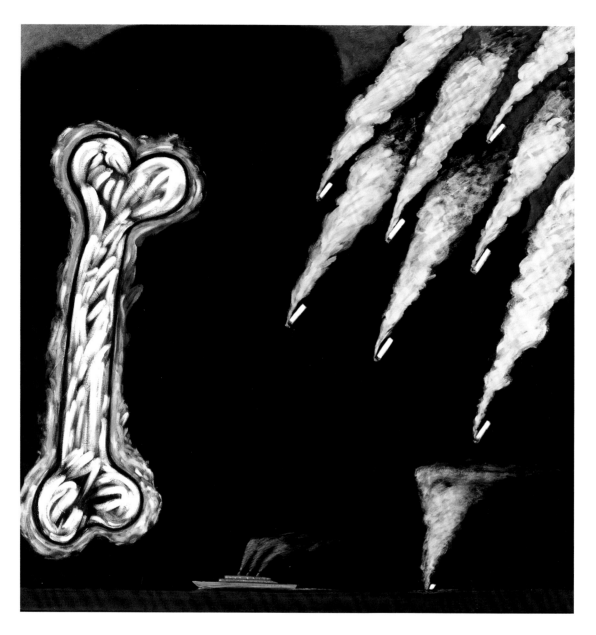

Gronk. *Getting the Fuck Out of the Way*. 1987. Oil on canvas, 48 x 48".
Collection Cheech and Patti Marin

Gronk. *Josephine Bonaparte Protecting the Rear Guard*. 1987. Acrylic on canvas, 60 x 72". Collection Joanna Giallelis

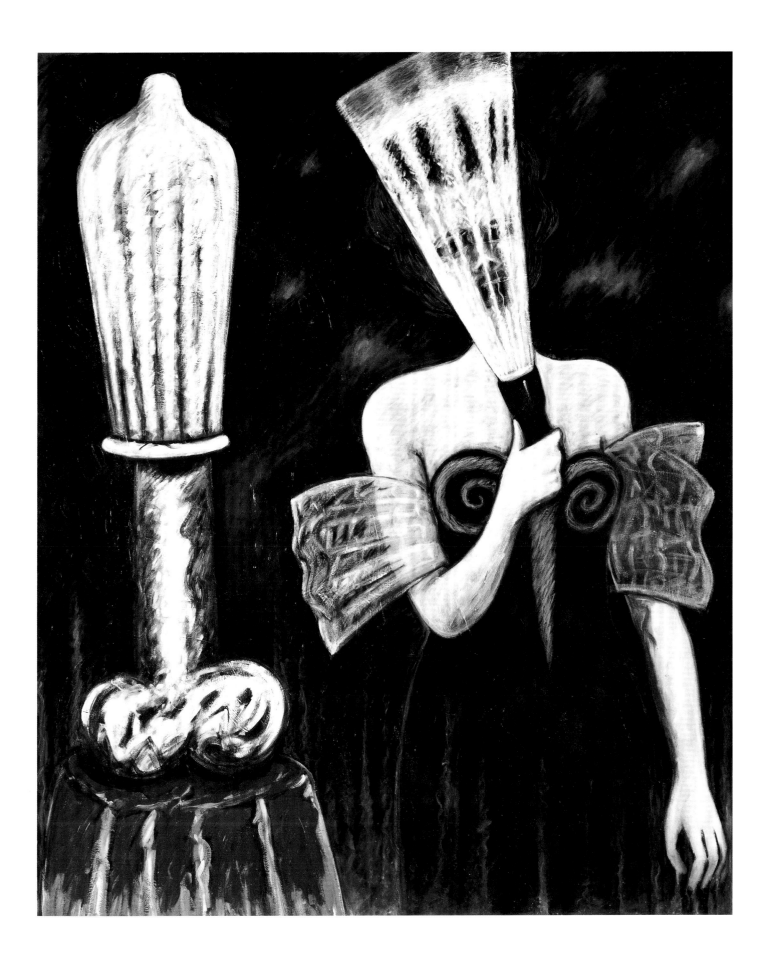

Gronk. *Hot Lips.* 1989. Acrylic on
canvas, 67 x 70". Collection William
Link and Margery Nelson

Gronk. *Pérdida (ACCENT ON THE e).*
(Lost). 2000. Mixed media on hand-
made paper mounted on wood,
118 x 60". Collection Cheech and
Patti Marin

*The natural evolution for Gronk into Chicano abstraction as the
background moves into and becomes the foreground.*

Raul Guerrero. *Club Coco Tijuana*.
1990. Gouache and chalk pastel on
Arches paper, 22¼ x 14¼".
Collection Cheech and Patti Marin

This pastel and Molino Rojo, *opposite, recall my youthful experiences in border town Tijuana, where I first experienced nightlife in bars and cafés. The pastel dance halls made by Henri Toulouse-Lautrec and Edgar Degas also reminded me of these wilder days.*

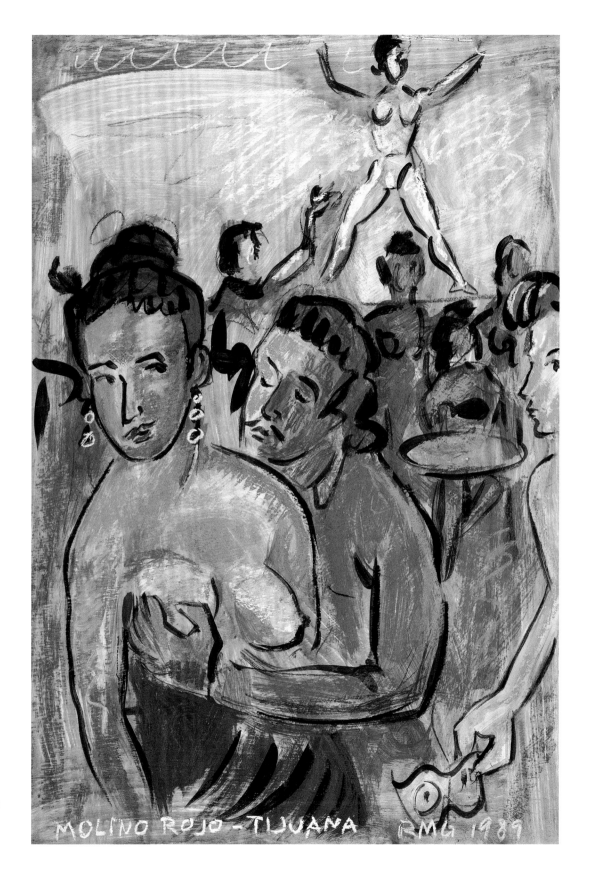

Raul Guerrero. *Molino Rojo*
(Moulin Rouge). 1989. Arches paper,
pastel, and gouache, 15 x 22".
Collection Cheech and Patti Marin

Wayne Alaniz Healy. *Beautiful Downtown Boyle Heights*. 1993. Acrylic on canvas, 94 x 69¾". Collection Cheech and Patti Marin

Norman Rockwell meets Jackson Pollock in East L.A. Healy represents the perfect blend of these influences.

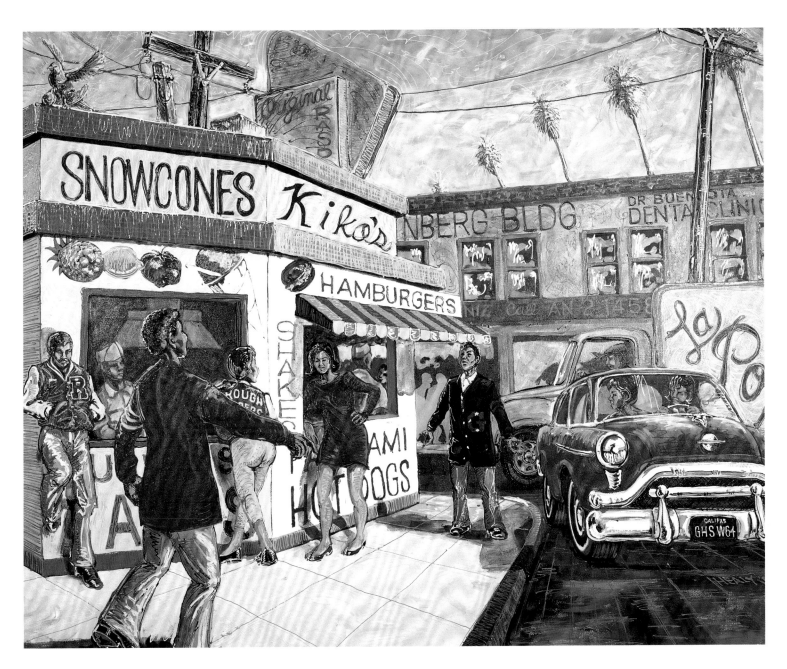

Wayne Alaniz Healy. *Pre-Game Warmup*. 2001. Acrylic on canvas, 120 x 96". Collection Cheech and Patti Marin

Wayne Alaniz Healy. *Una Tarde en Meoqui* (An Afternoon in Meoqui). 1991. Acrylic on canvas, 53½ x 53¾". Collection Cheech and Patti Marin

Una Tarde en Meoqui, detail

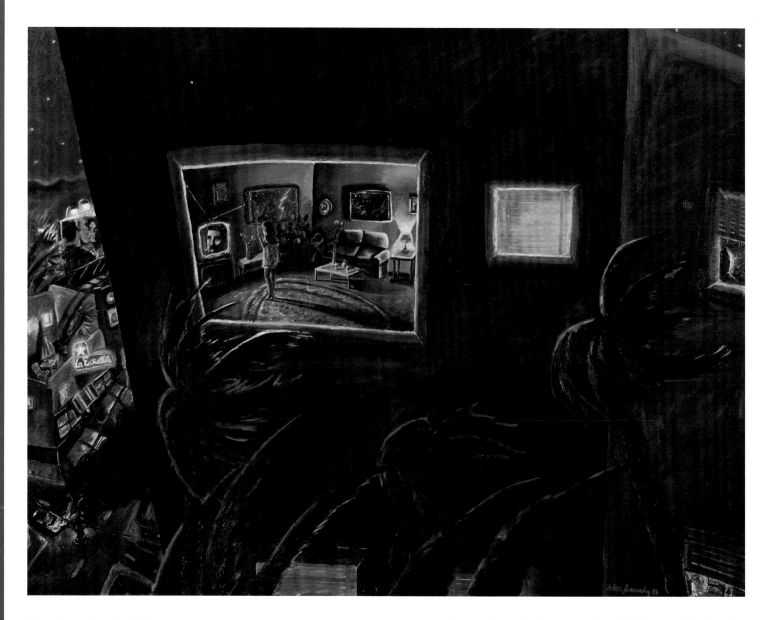

Adan Hernández. *Sin Título II*
(Untitled). 1988. Oil on canvas,
60 x 46". Collection Lisa Ortiz

The master and probable inventor of "Chicano Noir." Here the
palm trees are always in motion—regardless of the weather.

Adan Hernández. *La Estrella que Cae* (The Falling Star). 1991. Oil on canvas, 48 x 58". Collection Cheech and Patti Marin

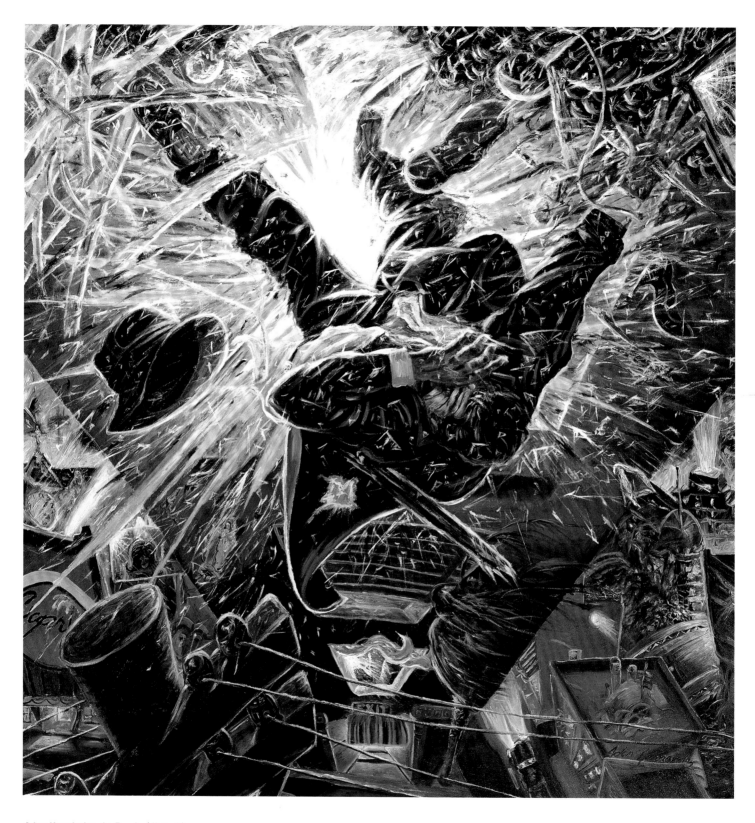

Adan Hernández. *La Bomba* (diptych).
1992. Oil on canvas, 57 x 59" overall.
Collection Cheech and Patti Marin

Adan Hernández. *Drive-by Asesino*
(diptych). 1992. Oil on canvas, 55 x
60¼" overall. Collection Cheech and
Patti Marin

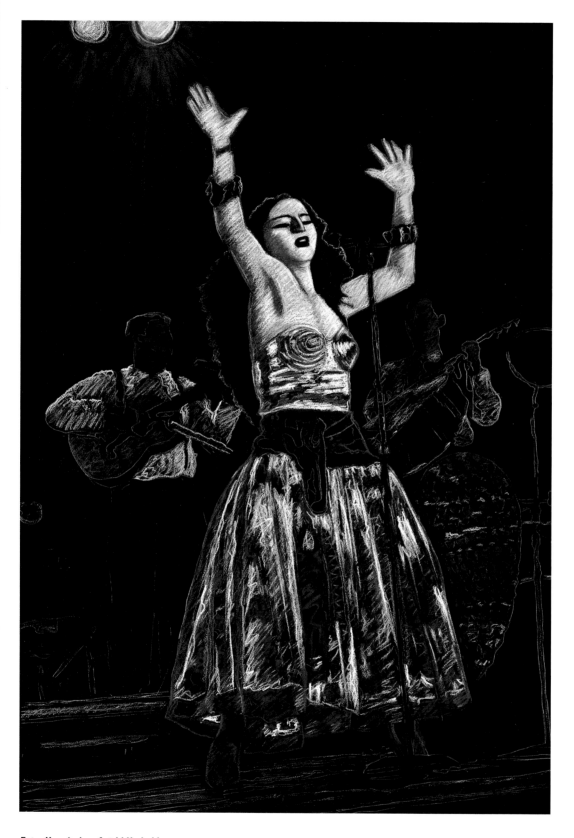

Ester Hernández. *Astrid Hadad in
San Francisco*. 1994. Pastel on
paper, 30 x 44". Collection Cheech
and Patti Marin

Leo Limón. *Frida and Palomas.* 2001.
Acrylic on canvas, 24 x 36".
Collection Cheech and Patti Marin

Leo Limón. *Un Poquito Sol.* 1991.
Acrylic on canvas, 47¼ x 59".
Collection Cheech and Patti Marin

Leo Limón. *Mas Juegos* (More Games). 2000. Acrylic on canvas, 48 x 69¾". Collection Cheech and Patti Marin

Leo Limón. *Cup of Tochtli.* 1997.
Pastel on paper, 20½ x 19½".
Collection Cheech and Patti Marin

Together with Carlos Almaraz, Leo Limón originated the swirling Chicano iconography, whose symbols are rooted in ancient myth and laden with personal meaning.

Leo Limón. *Wild Ride*. 1996. Pastel
on paper, 25¼ x 19". Collection
Cheech and Patti Marin

Leo Limón. *Ay! Dream of Chico's Corazon* (Dream of Chico's Heart). 1992. Acrylic on canvas, 10½ x 13½". Collection Cheech and Patti Marin

Although not much bigger than a regular sheet of paper, this painting makes a big statement.

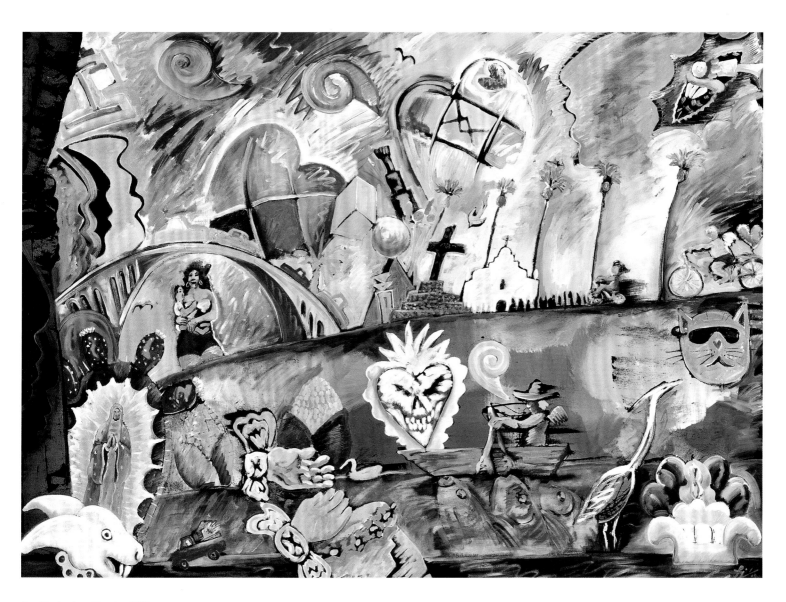

Leo Limón. *Los Muertos.* 1998.
Acrylic on canvas, 56 x 40".
Collection Cheech and Patti Marin

Gilbert Lujan. *Blue Dog*. 1990.
Pastel on paper, 44 x 30".
Collection Cheech and Patti
Marin

The homeboy who never lost his sense of playfulness.

Gilbert Lujan. *Boy and Dog*.
1990. Pastel on paper, 44 x 30".
Collection Cheech and Patti
Marin

César Martínez. *Bato con Sunglasses*. 2000. Oil on canvas, 44 x 54". Collection Cheech and Patti Marin

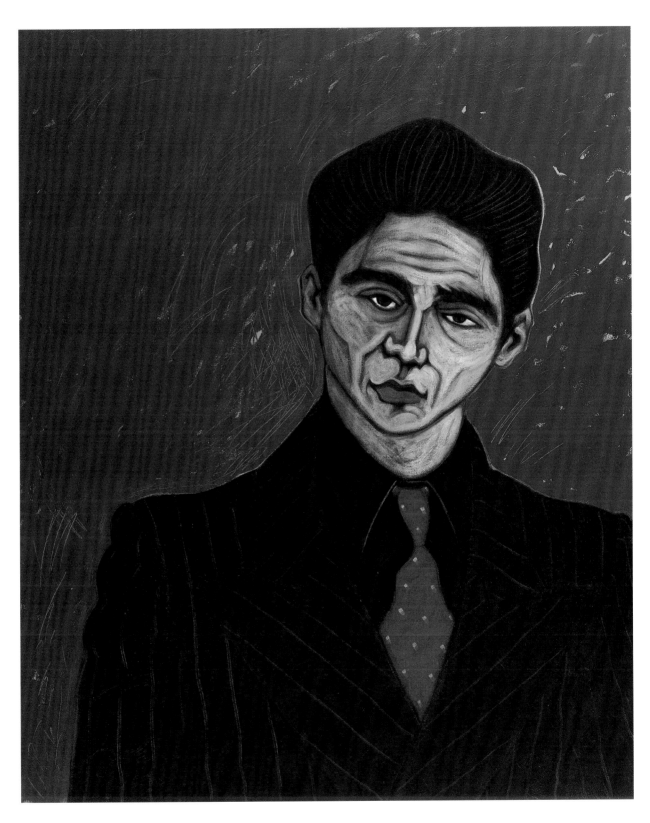

César Martínez. *El Guero* (The Light-Skinned One). 1987. Oil on canvas, 44 x 54". Collection Cheech and Patti Marin

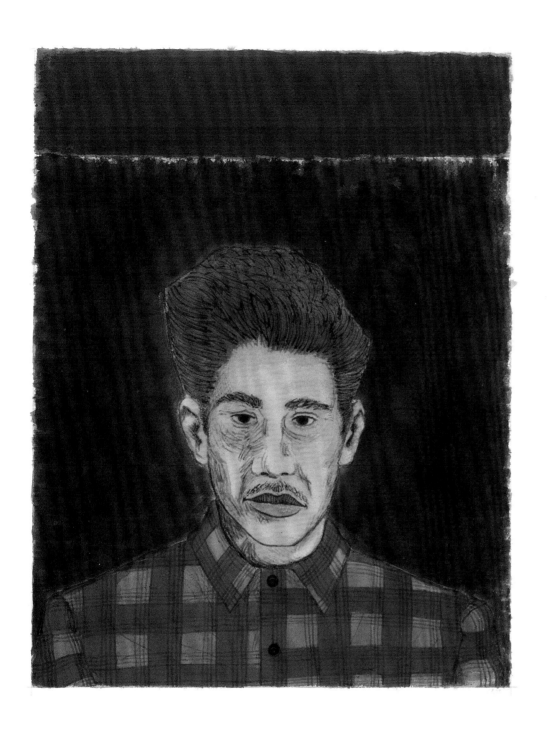

César Martínez. *Camisa de Cuadros*
(Shirt with Squares). 1990.
Watercolor on paper, 14 x 18".
Collection Cheech and Patti Marin

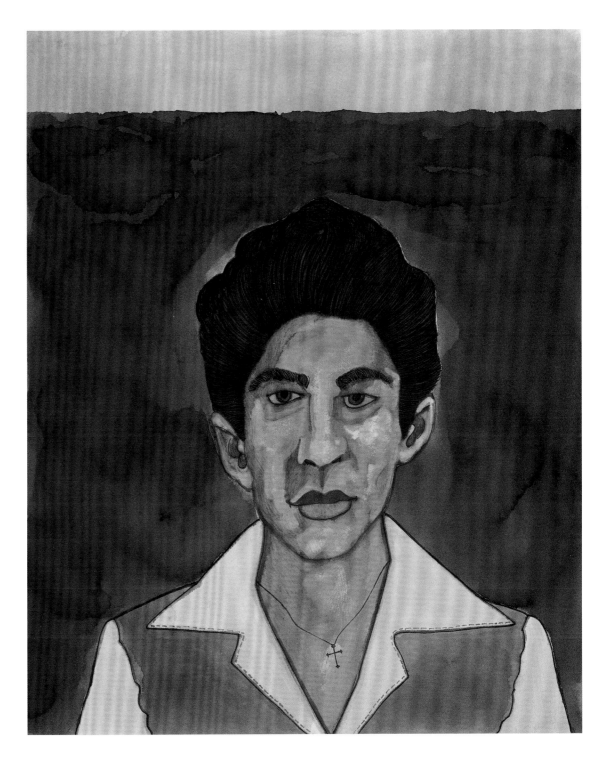

César Martínez. *Bato con Cruz*
(Dude with Cross). 1993. Watercolor
on paper, 17³⁄₄ x 21³⁄₄". Collection
Cheech and Patti Marin

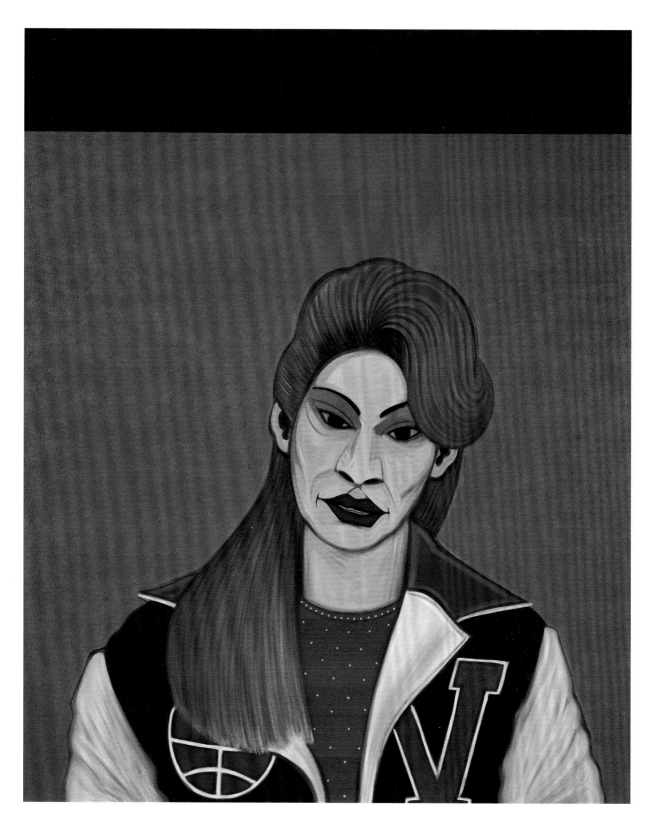

César Martínez. *Sylvia With Chago's Letter Jacket*. 2000. Oil on canvas, 44 x 54". Collection Cheech and Patti Marin

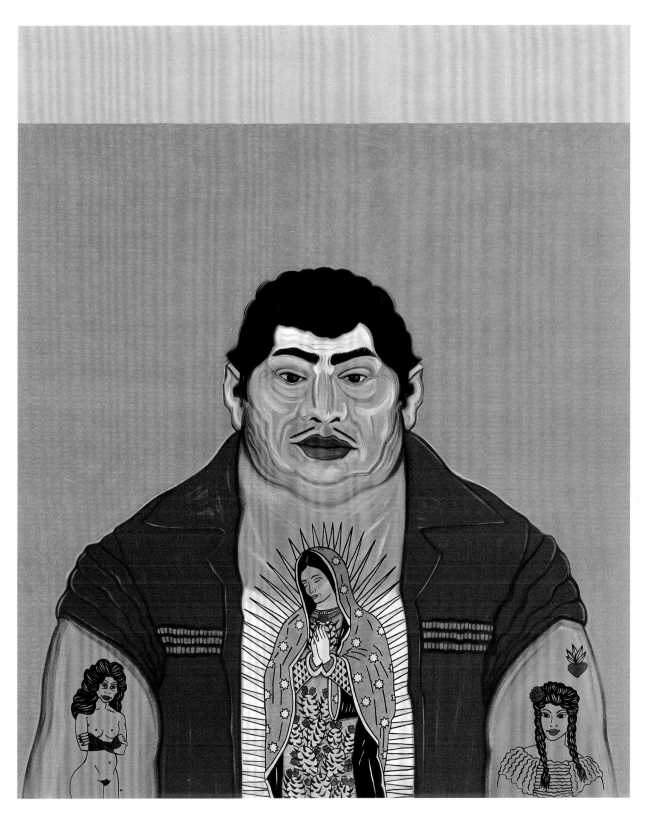

César Martínez. *Hombre que le Gustan las Mujeres* (The Man Who Loves Women). 2000. Oil on canvas, 44 x 54". Collection Cheech and Patti Marin

The Modigliani of the group. Martínez uses portraiture and Rothkoesque backgrounds to elevate local faces to hero status.

Frank Romero. *Downtown
Streetscape*. 2000. Oil on canvas,
52 x 40". Collection Cheech and
Patti Marin

Frank Romero. *Pink Landscape.*
1984. Oil on canvas, 60¼ x 36".
Collection Cheech and Patti Marin

Frank Romero. *íMéjico, Mexico!*
(4 panels). 1984. Mixed media,
288 x 120" overall. Collection
Cheech and Patti Marin

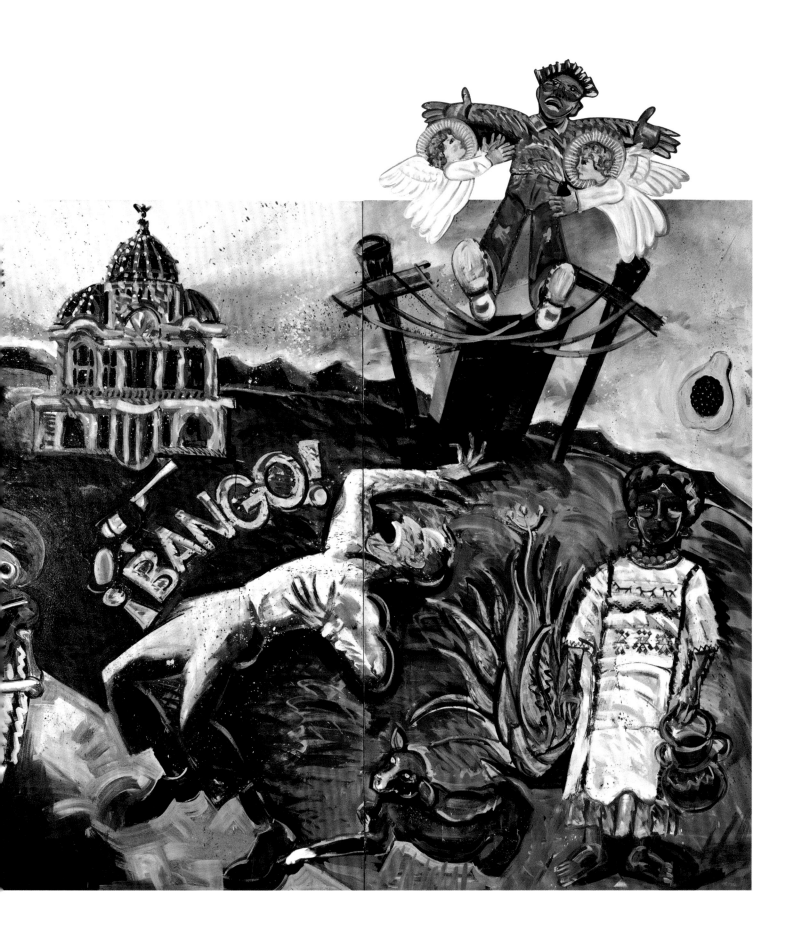

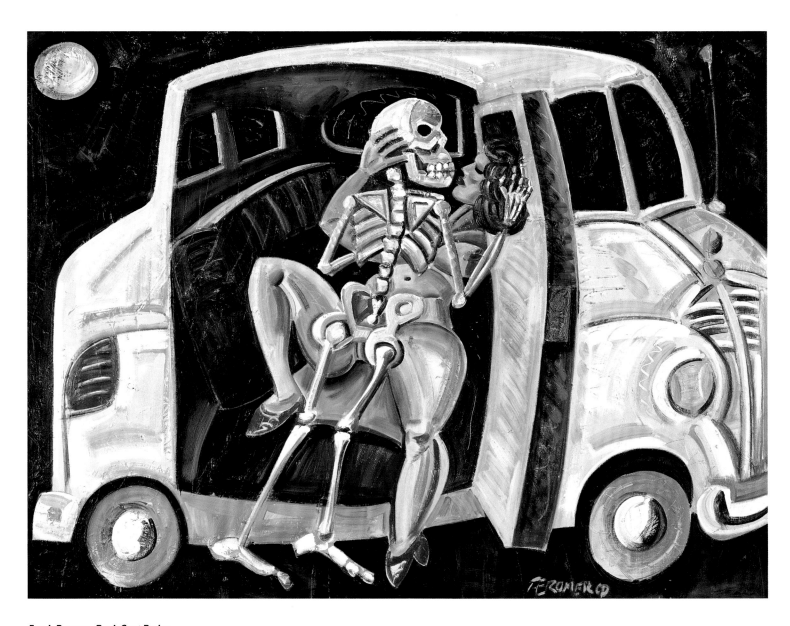

Frank Romero. *Back Seat Dodge,
Homage to Keinholtz*. 1991. Oil on
canvas, 47½ x 35½". Collection
Cheech and Patti Marin

*The Mexican myth of the woman
who killed her children and
wanders the landscape looking
for strays.*

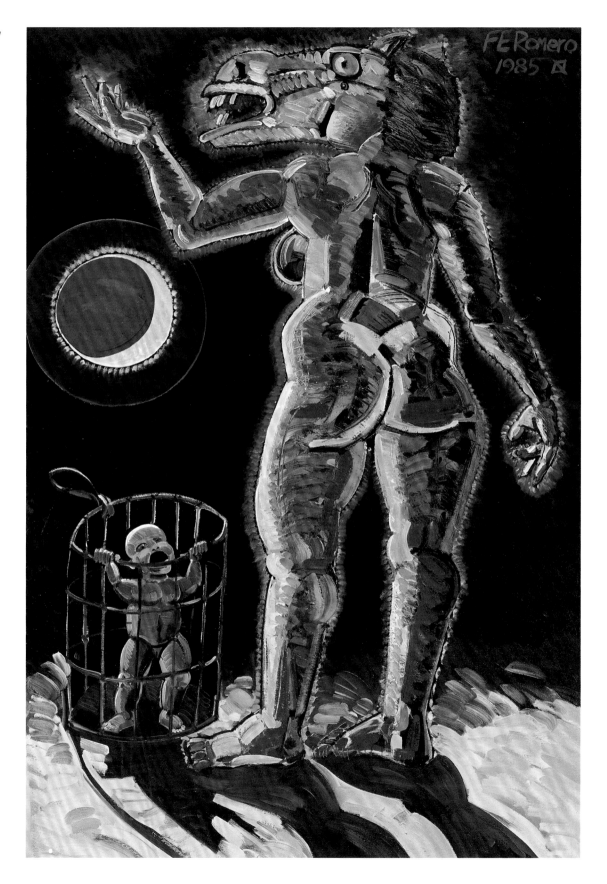

Frank Romero. *La Llorona* (The
Weeping Women). 1985. Oil on
canvas, 50 x 72". Collection Cheech
and Patti Marin

Frank Romero. *Cruising #1*. 1988.
Monoprint, 29½ x 22". Collection
Cheech and Patti Marin

Frank Romero. *Johanna*. 1991. Pastel
on paper, 40 x 22". Collection
Cheech and Patti Marin

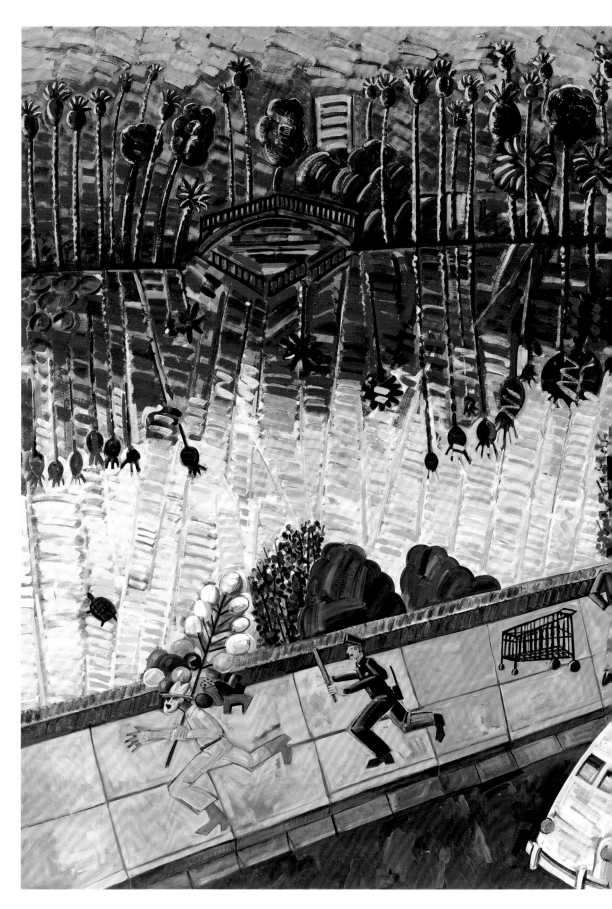

Frank Romero. *The Arrest of the Paleteros* (diptych). 1996. Oil on canvas, 144 x 96" overall. Collection Cheech and Patti Marin

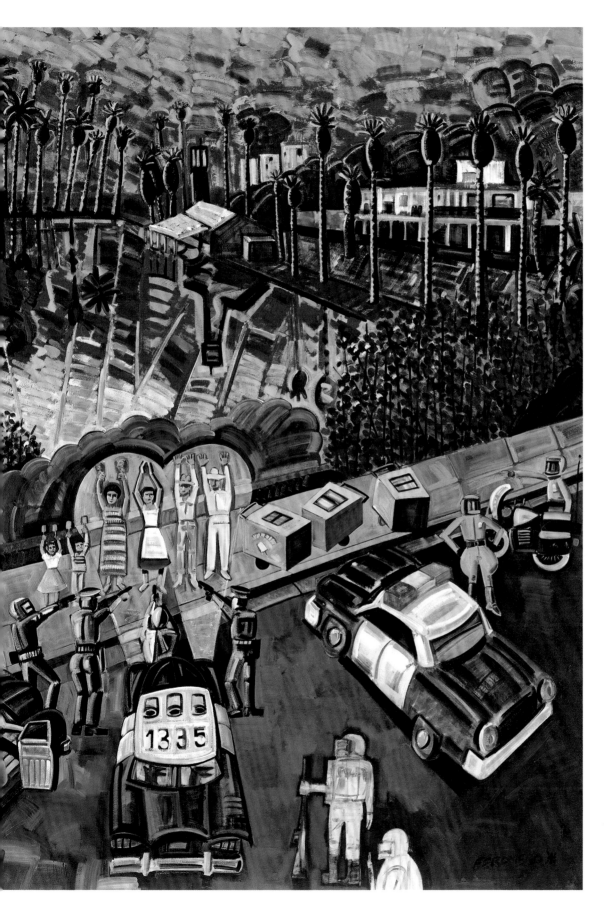

Paleteros, *or ice cream men,
were the most innocent and
representative of transplanted
Mexican culture in Los Angeles.
The fact that they were frequently
arrested for not having vendor
permits attests to the kind of
ludicrous racial prejudice that
exists beside the other truly
serious dangers of Echo Park.*

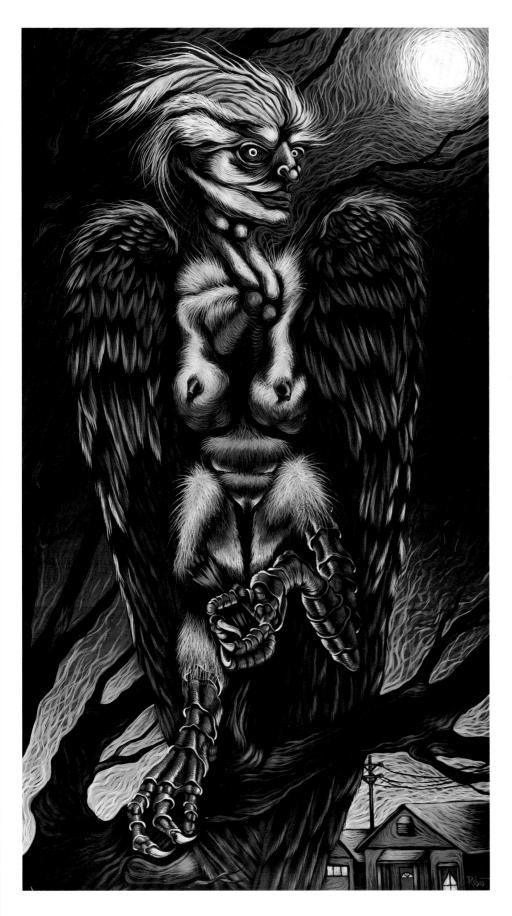

The owl woman is another Mexican bogey-man/bogeywoman. Seen with Romero's La Llorona, *page 113, the two paintings contrast the old school (Romero) with the new school of Chicano art (Rubio).*

Considering the size of the work and the amount of detail and texture, it's interesting to note that the artist only used the same-size paintbrush throughout.

Alex Rubio. *La Lechuza* **(The Owl Woman). 2001. Oil on wood panel, 48 x 84". Collection Cheech and Patti Marin**

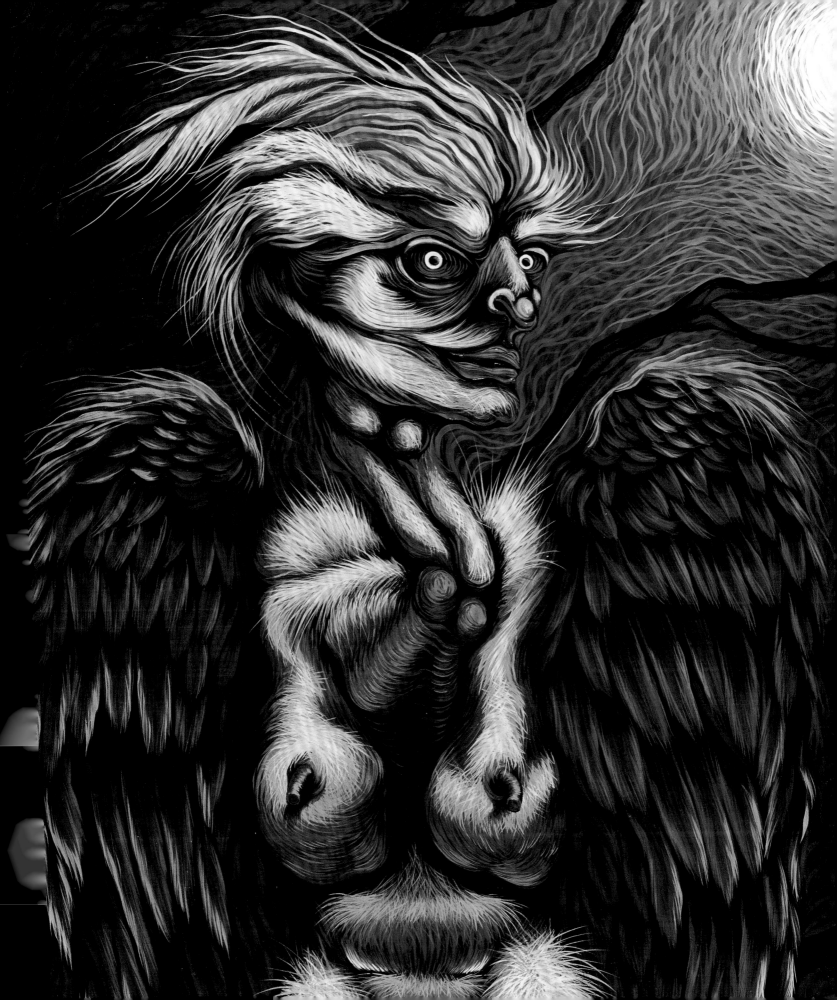

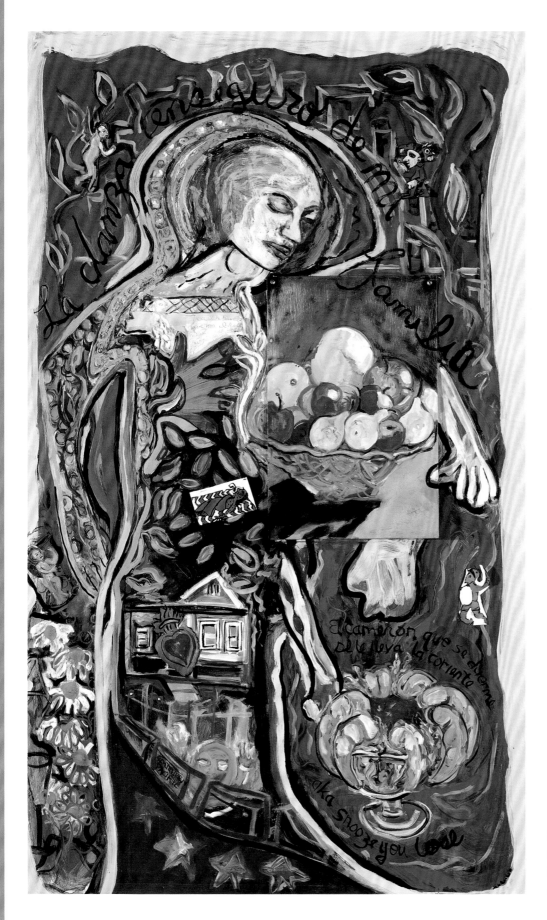

Marta Sánchez. *La Danza* (The Dance). 1994. Oil enamel on metal, 35½ x 59½". Collection Cheech and Patti Marin

Eloy Torrez. *Herbert Siguenza*. 2000.
Oil on canvas, 15 x 19". Collection
Cheech and Patti Marin

Eloy Torrez. *The Red Floor*. 1990.
Acrylic on paper, 35 x 55".
Collection Cheech and Patti Marin

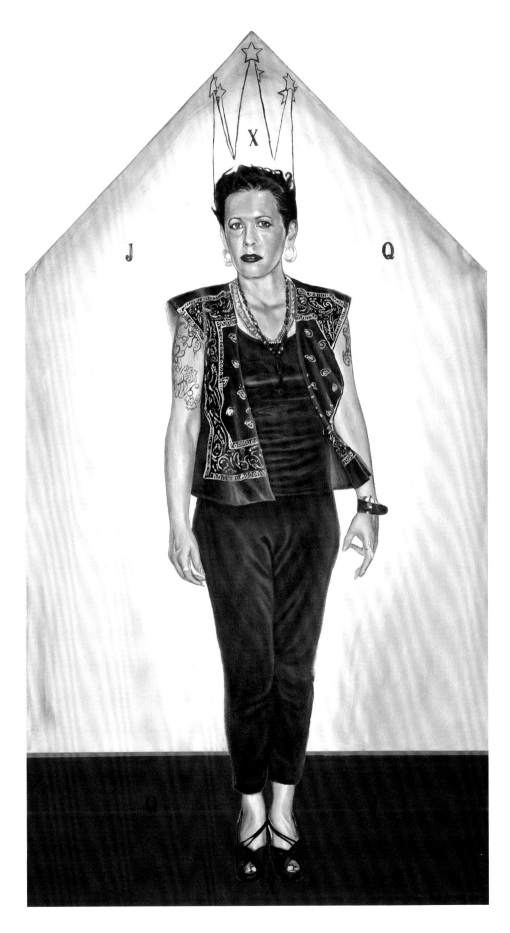

Eloy Torrez. *Diane Gamboa*. 2000.
Oil on canvas, 18¼ x 33". Collection
Cheech and Patti Marin

Jesse Treviño. *Guadalupe y
Calaveras.* 1976. Acrylic on canvas,
66 x 48". Collection Terry Vasquez

Jesse Treviño. *Los Piscadores.* 1985.
Acrylic on canvas, 82 x 48".
Collection Judge Juan F. Vasquez

John Valadez. *Pool Party*. 1986.
Oil on canvas, 107 x 69". Collection
Cheech and Patti Marin

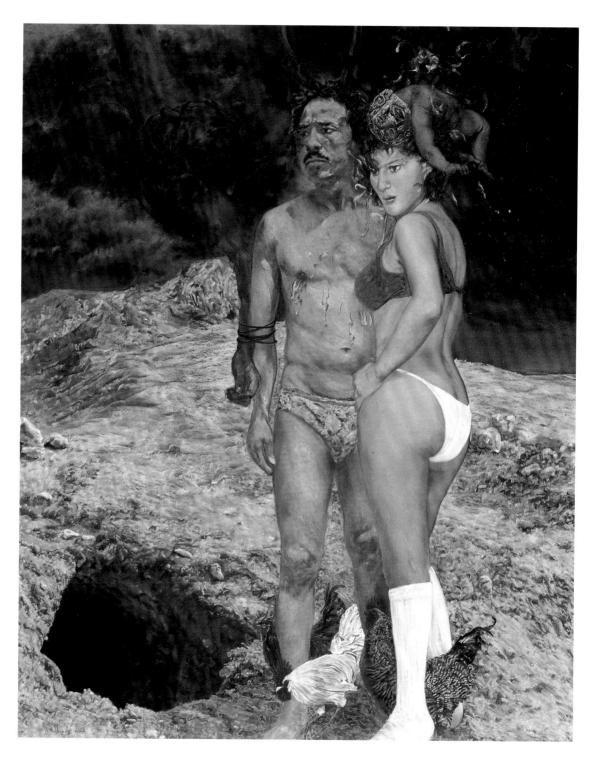

John Valadez. *Revelations.* 1991.
Pastel on paper, 50½ x 61".
Collection Cheech and Patti Marin

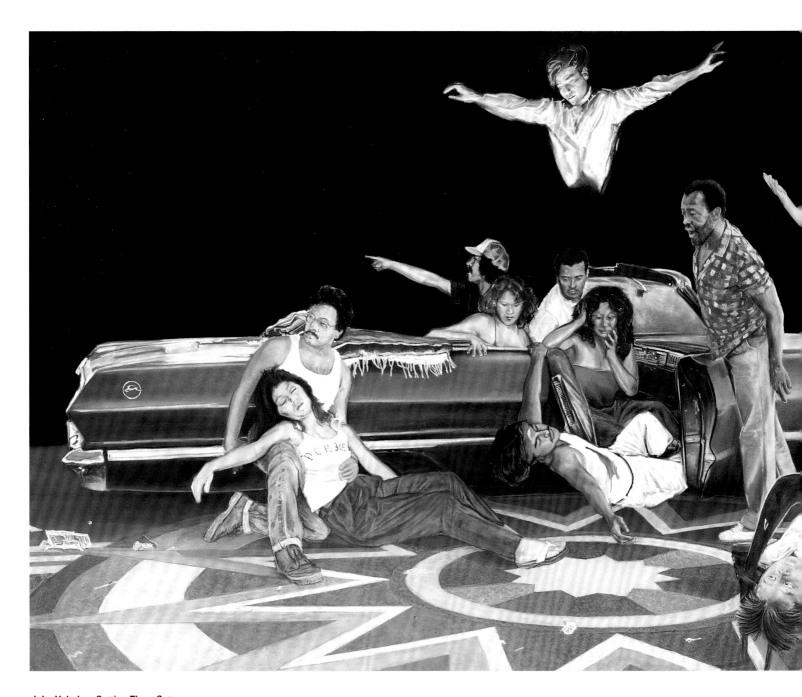

John Valadez. *Getting Them Out
of the Car*. 1984. Pastel on paper,
100 x 37½". Collection Cheech and
Patti Marin

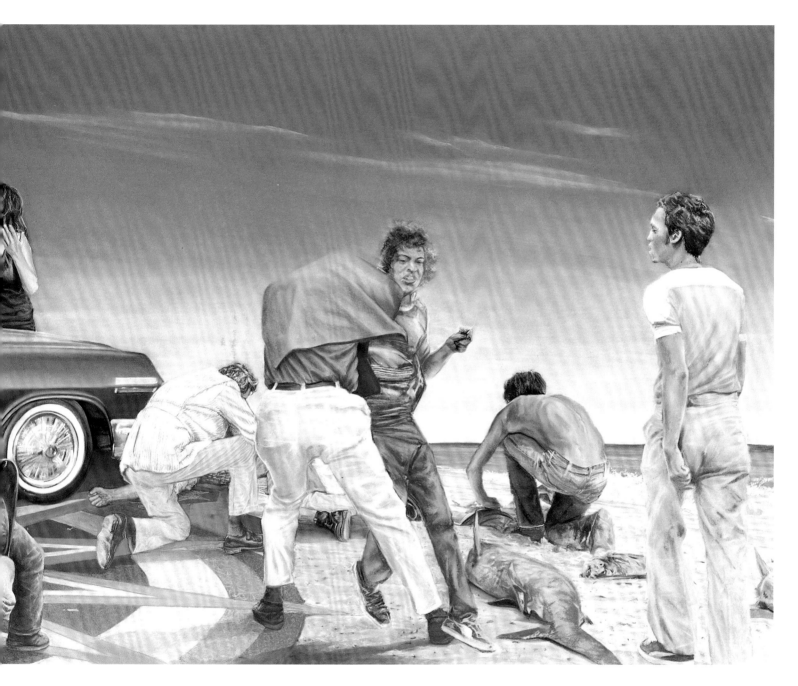

Valadez excels as a master Photorealist, which is even more difficult to achieve when working in pastel. Ginger Rogers once remarked that she did everything that Fred Astaire did, only backwards and in high heels.

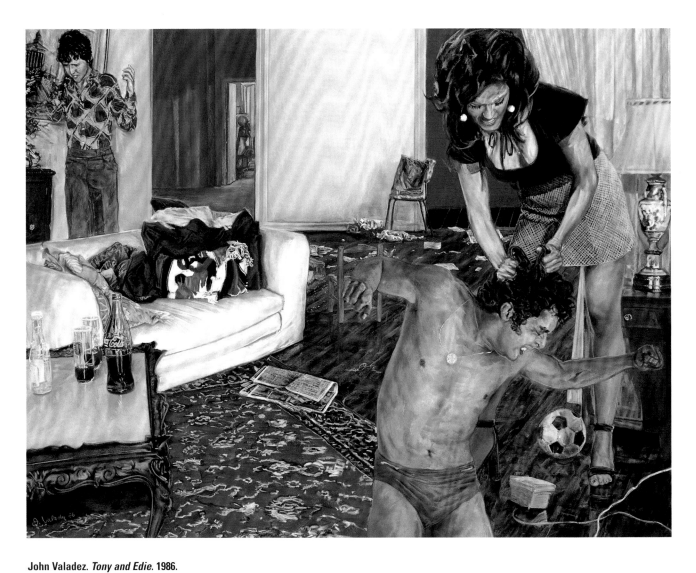

John Valadez. *Tony and Edie*. 1986.
Pastel on paper, 50 x 38". Collection
Robert Berman

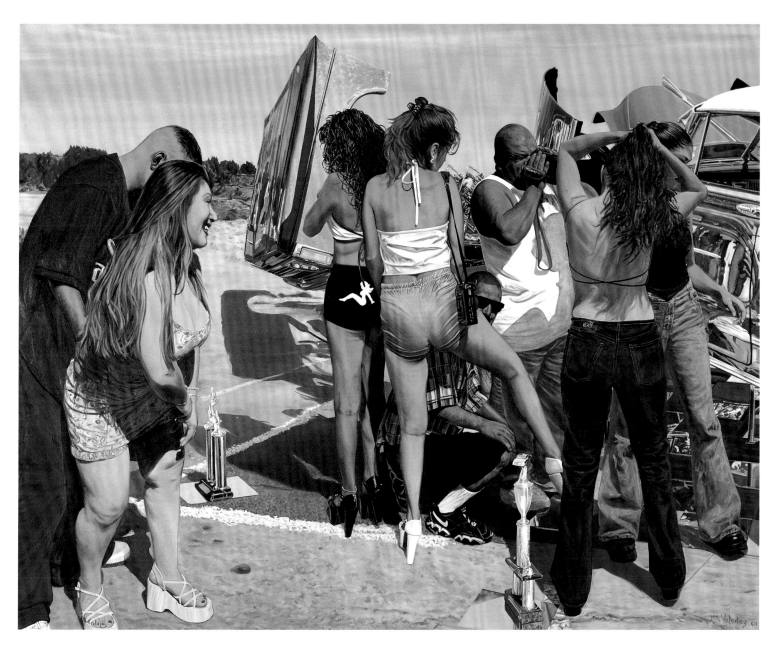

John Valadez. *Car Show*. 2001.
Oil on canvas, 96¼ x 76". Collection
Dennis Hopper

John Valadez. *Beto's Vacation*
(Water, Land, Fire) (triptych). 1985.
Pastel on paper, 50 x 68", 50 x 72",
50 x 68". Collection Dennis Hopper

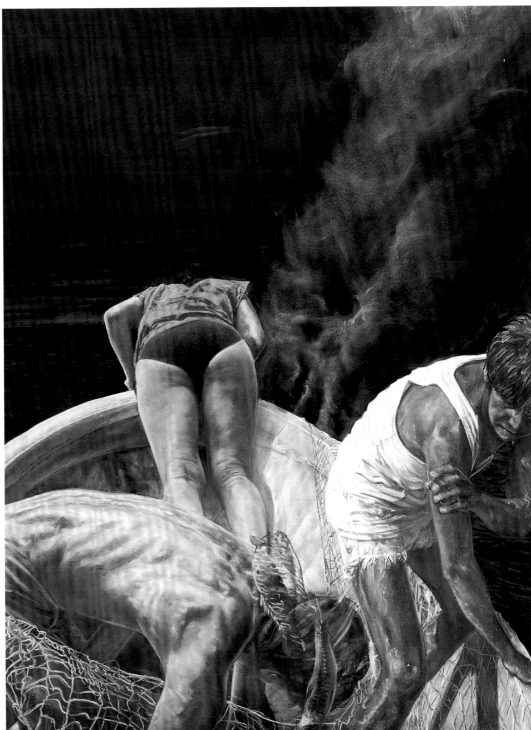

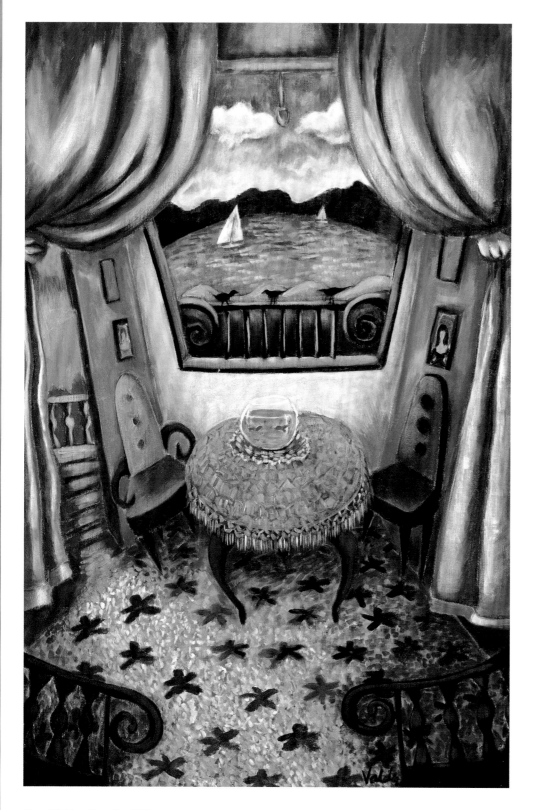

Patssi Valdez. *Saturday.* 1997.
Acrylic on canvas, 24 x 36".
Collection Cheech and Patti Marin

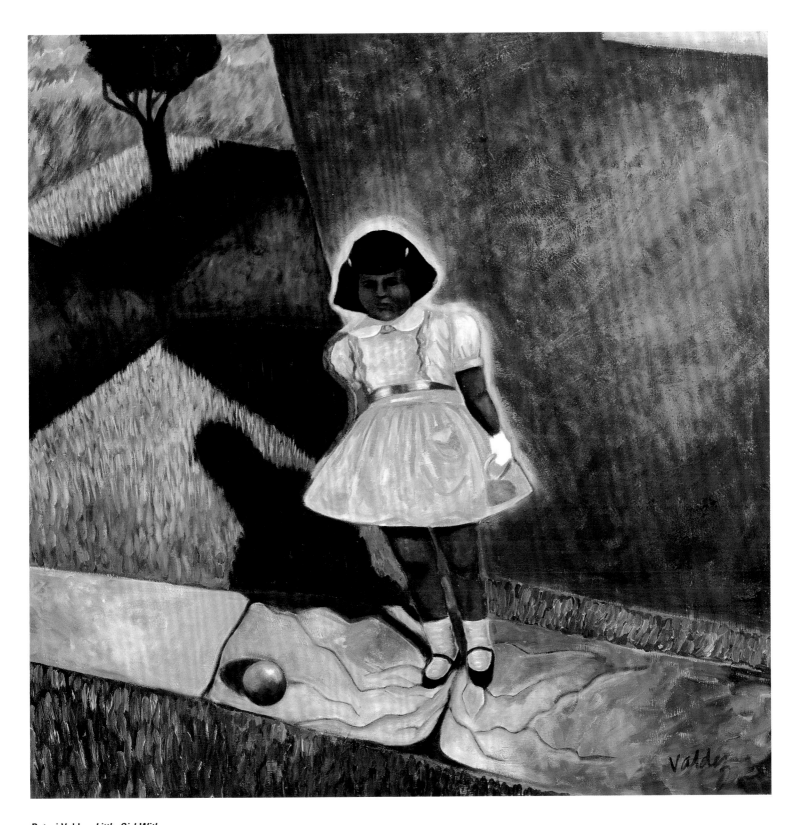

Patssi Valdez. *Little Girl With
Yellow Dress*. 1995. Acrylic on
canvas, 36 x 36". Collection Cheech
and Patti Marin

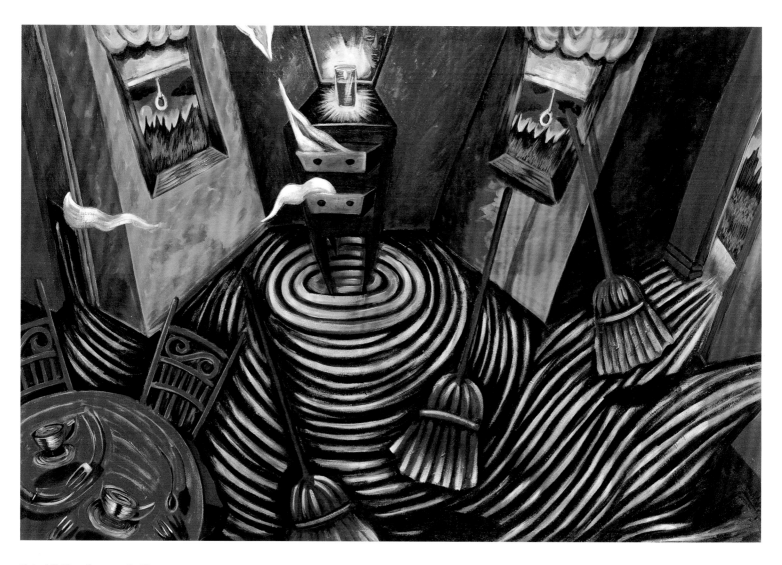

Patssi Valdez. *Room on the Verge*.
1993. Acrylic on canvas, 72 x 48".
Collection Cheech and Patti Marin

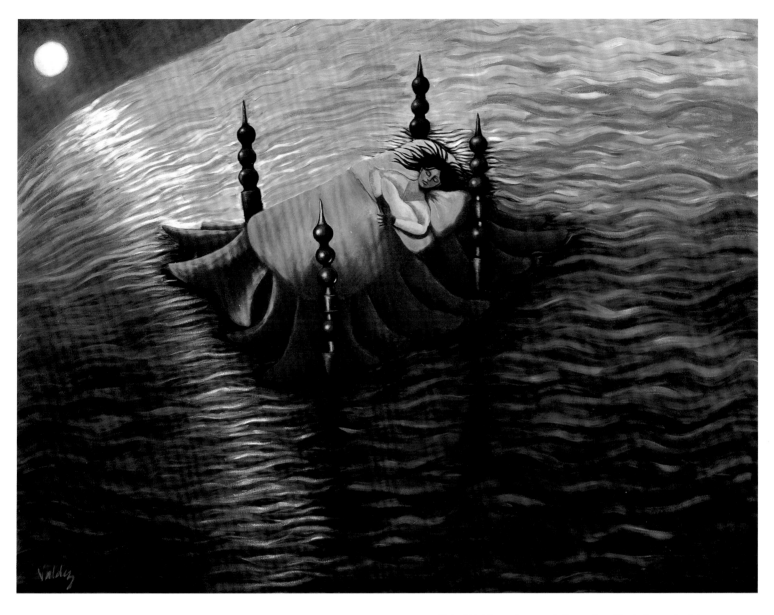

Patssi Valdez. *The Dream*. 2000.
Acrylic on canvas, 96 x 72".
Collection the artist

Patssi Valdez, whose paintings glow like holy cards, takes you on an emotional journey while never leaving her room.

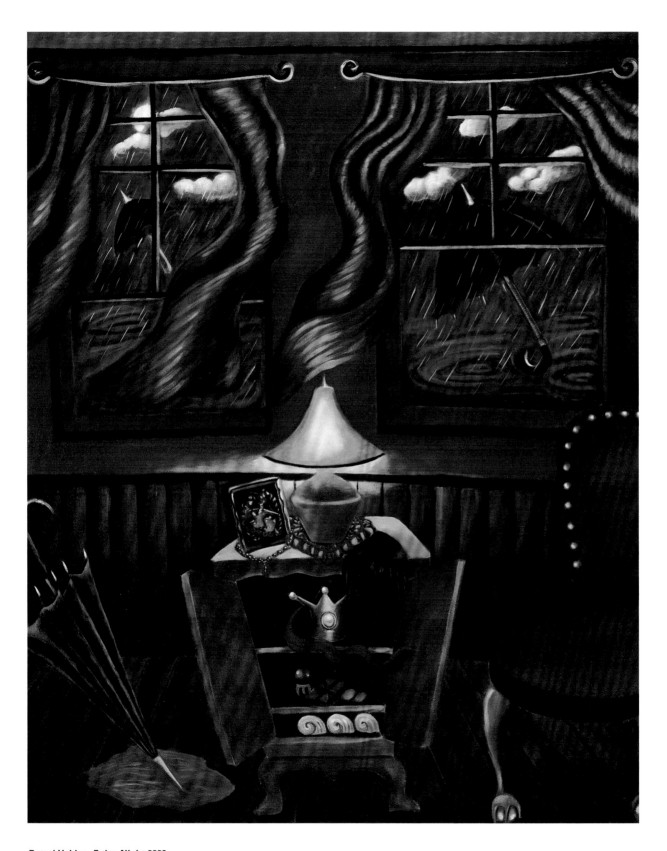

Patssi Valdez. *Rainy Night.* 2000.
Acrylic on canvas, 53 x 66".
Collection Cheech and Patti Marin

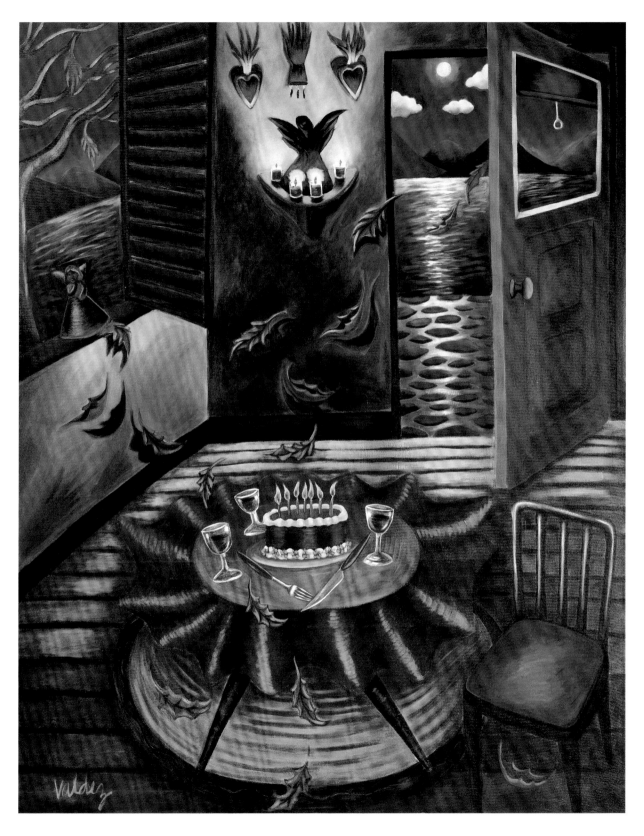

Patssi Valdez. *Autumn*. 2000. Acrylic
on canvas, 52 x 66". Collection
Cheech and Patti Marin

Patssi Valdez. *Broken Dreams.* 1988.
Acrylic on canvas, 36¼ x 36½".
Collection Cheech and Patti Marin

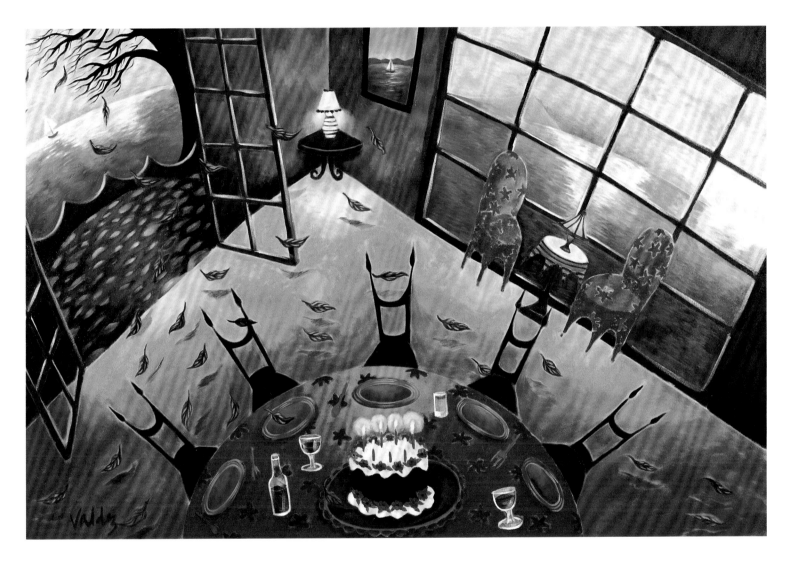

Patssi Valdez. *Happy Birthday*. 2000.
Acrylic on canvas, 72 x 48".
Collection Cheech and Patti Marin

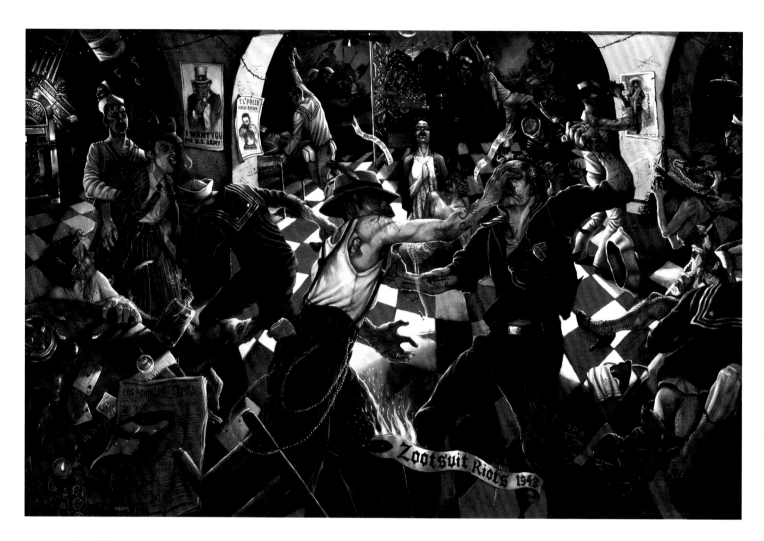

Vincent Valdez. *Kill the Pachuco Bastard!*. 2001. Oil on canvas, 72 x 48". Collection Cheech and Patti Marin

Valdez, the youngest painter of the artists shown here, is a recent graduate of the Rhode Island School of Design. It speaks well of the concept of a "Chicano School of Painting" when its youngest member chooses to depict one of the seminal events of Chicano history, the zoot suit riots of the 1940s.

Kill the Pachuco Bastard!, detail

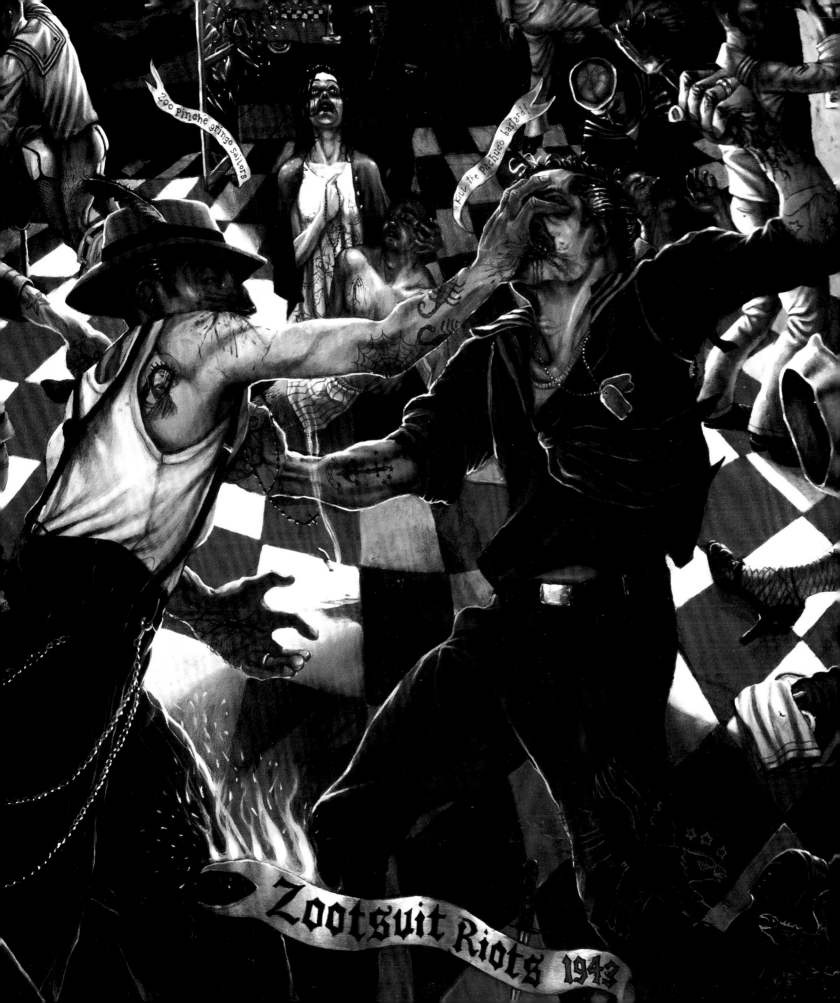

Zootsuit Riots 1943

George Yepes. *La Pistola y el Corazon* (The Pistol and the Heart). 1989. Serigraph, 34 x 42". Collection Cheech and Patti Marin

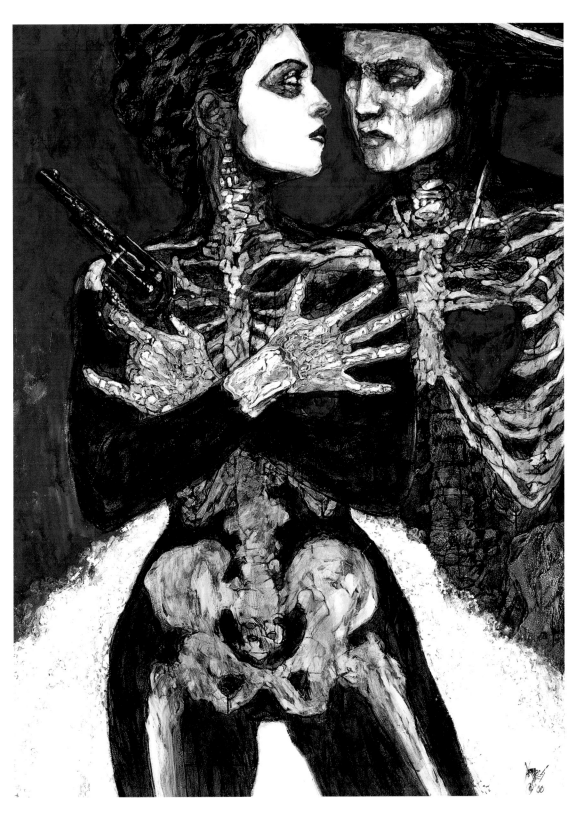

George Yepes. *La Pistola y el Corazon* (The Pistol and the Heart). 2000. Oil on canvas, 60 x 81½". Collection Cheech and Patti Marin

The original painting, which was much smaller, was owned by Sean Penn. A few years back, it was lost in a trailer fire. Yepes painted this larger one especially for the exhibition.

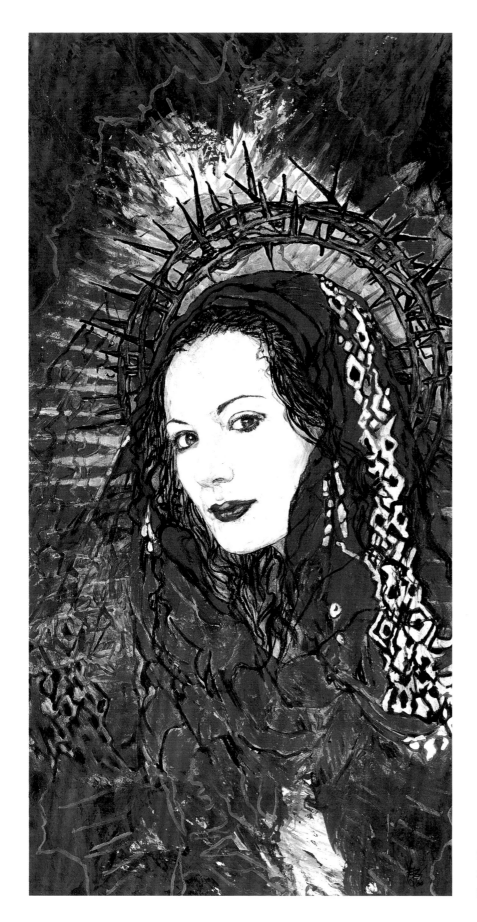

George Yepes. *La Magdalena*. 2000.
Oil on canvas, 41 x 80". Collection
Cheech and Patti Marin

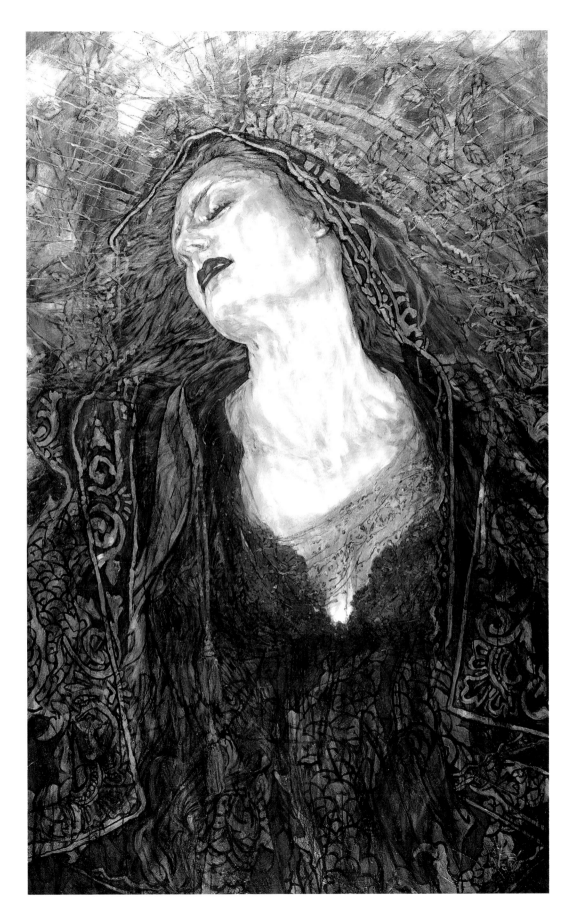

George Yepes. *Axis Bold as Love*.
2001. Acrylic on canvas, 60 x 96".
Collection Cheech and Patti Marin

BIOGRAPHIES OF THE ARTISTS

Carlos Almaraz

Carlos Almaraz was born in Mexico City in 1949 and grew up in Chicago and Los Angeles. He studied at the University of California, Los Angeles, and later earned a Master's degree in fine arts from Otis College of Art and Design in 1974. In 1973, Almaraz and three other artists cofounded Los Four, a local art collective whose collaborations brought Chicano street art to the attention of the Los Angeles mainstream art community. Almaraz also created murals, banners, and other artworks for César Chávez and the United Farmworkers Union. His large *Boycott Gallo* mural on the All Nations' Center in East Los Angeles was a community landmark before its destruction during the late 1980s.

Over a period of twenty-five years, Almaraz continually drew, wrote poems, and kept faithful accounts of his ideas in some fifty notebooks, chronicling the evolution of his distinct lexicon of characters, symbols, and concepts. Although Almaraz died in 1989, his pastels, paintings, and murals remain a major influence on younger Latino artists. His work continues to be widely exhibited in solo and group shows throughout the world.

Charles "Chaz" Bojórquez

Charles Bojórquez, a resident of Mt. Washington, California, began his art career by spray-painting along riverbeds. He spent a summer at art school in Guadalajara, Mexico, and attended classes at Chouinard Art Institute (now Cal Arts) the year before graduating from high school in 1967. By the end of 1969, Bojórquez created a symbol that represented himself and the streets—a stylized skull called "*Señor Suerte*," or "Mr. Luck." It has become a gangster image of protection from death.

Three of Bojórquez's paintings are now in the permanent collection of the National Museum of American Art in Washington, D.C. Four other works, which reflect the culture of Southern California, are owned by the Orange County Museum of Art. Bojórquez is considered one of the few Chicano artists who have successfully made the transition from the street to the gallery.

David Botello

David Botello, a native of East Los Angeles and Lincoln Heights, is best known as one of the East Los Streetscapers. Botello founded Goez Art Studio and Gallery, one of the first Chicano art galleries, in 1969 and in 1973 was among the first to do a mural at Estrada Courts. Botello rediscovered his third-grade art partner, Wayne Healy, in 1975, and left the gallery to paint murals with him.

Shortly thereafter, artists such as George Yepes and Rudy Calderón began working with Botello and Healy and the group became the East Los Streetscapers. While other artists have come and gone, Botello and Healy remain the core of the team. In addition to their many local murals, they have done projects in Houston, St. Louis, and Bellingham, Washington, as well as in San Jose and Santa Maria, California. Botello lives in El Sereno, just north of East Los Angeles.

Mel Casas

Mel Casas was born in El Paso, Texas, in 1929. He earned a Bachelor of Arts degree from Texas Western College in 1956 and a Master of Arts degree from the University of the Americas, Mexico City, in 1958.

Television and movie screens play an important role in Casas's series entitled "Humanscapes." The artist says, "I can't deal without propaganda. . . . We are bombarded by this constantly on TV." Casas had been more involved with sociopolitical and economic problems, paying particular attention to the Mexican American, the migrant worker, youth, and other "outsider" groups. Casas has had one-man shows in Mexico City, El Paso, San Antonio, and Seguin, Texas.

Gaspar Enríquez

El Paso-born Gaspar Enríquez received his art training in Los Angeles, the University of Texas at El Paso, where he received a Bachelor of Arts degree, and New Mexico State University, where he received a Master of Arts degree. Enríquez teaches art at Hispanic Bowie High School on the El Paso/Juárez border. His students often provide inspiration for his work. Enríquez has been included in numerous exhibitions, including the national tour "CARA—Chicano Art: Resistance and Affirmation 1965-1985." He provides a significant voice for the communities along the U.S./Mexico border.

In describing one of his works, Enríquez said, "one is born a Mexican-American, but one chooses to be a Chicano. Politically charged, the Chicano lifestyle has been passed from one generation to another. It has survived wars, prisons, and strife."

Diane Gamboa

Diane Gamboa has been exhibited nationally and internationally for several years. She has done collaborative work with the conceptual/performance/visual arts group Asco, and has appeared in several publications. Her paper fashions have been featured in the landmark national tour "CARA—Chicano Art: Resistance and Affirmation 1965–1985." Gamboa's work has been included in several large exhibits in recent years. The Los Angeles County Museum of Art acquired her work, *Red Bitch*, for exhibition in the show "Image and Identity."

Margaret García

Margaret García studied at California State University, Northridge, Los Angeles City College, and the University of Southern California, where she received her Master's degree in fine arts in 1992. Her work has been exhibited in group shows throughout Southern California as well as in Texas and Mexico. García teaches and lectures extensively on art in different cultures. She has said that her work "provides a look at my community through the presence of the individual." Although she does not consider her portraits overtly political or even socially conscious, in time she has come to realize that their very specificity belies the stereotypes given to any one culture by the media.

Rupert García

Rupert García, born in French Camp, California, studied painting and received numerous student honors from Stockton Junior College and San Francisco State University, where he was influenced by Photorealism. One of the leading artists in the Chicano movement in the Bay Area of the late 1960s and early 1970s, García participated

in the formation of several seminal West Coast civil rights movement–oriented workshops and collectives, including Galería de la Raza and the San Francisco Poster Workshop.

García has received numerous awards and honors, including an individual artist fellowship grant from the National Endowment for the Arts, the President's Scholar Award from San Jose State University, where he has taught in the School of Art and Design since 1988, and the College Art Association's Distinguished Award for Lifetime Achievement. In 1995, he received the National Hispanic Academy of Media Arts and Sciences' Lifetime Achievement Award in Art.

The bulk of García's work is housed in the National Archives of American Art at the Smithsonian Institution in Washington, D.C. In 1983, García wrote the first major study of Mexican painter Frida Kahlo titled *Frida Kahlo: A Bibliography and Biographical Introduction*.

Carmen Lomas Garza

Carmen Lomas Garza was born in Kingsville, Texas. Garza has a Bachelor of Science degree from Texas A&I University (currently Texas A&M University, Kingsville) where she studied art education and studio art, as well as a Master's degree in education from Antioch Graduate School-Juárez/Lincoln Center and a Master of Arts degree from San Francisco State University, where she concentrated on lithography and painting in oil and gouache.

Garza has had several solo exhibitions in U.S. museums, including the Hirshhorn Museum and the Whitney Museum of American Art. In 1991, she had a solo exhibition, "Pedacito de mi Corazón/A Piece of My Heart," at Laguna Gloria Art Museum, Austin, which traveled to several galleries and museums.

Garza is the recipient of two fellowships from the National Endowment for the Arts and the California Arts Council. In 1990, Children's Book Press of San Francisco published a bilingual collection of Garza's paintings and short stories, *Family Pictures/Cuadros de familia*, and in 1996 published *In My Family/En mi familia*.

Glugio "Gronk" Nicandro

Glugio "Gronk" Nicandro has always used his middle name, Gronk, a Brazilian-Indian word that means "to fly." He first came to the attention of the art world at the age of sixteen when, along with Harry Gamboa, Jr., Willy Herron, and Patssi Valdez, he became one of the founders of Asco. The Los Angeles-based Chicano artists' collaborative was among the first to incorporate political activism into its aesthetic.

Although Gronk sympathizes with many Chicano political and social causes, he does not use them as the basis of his art. Since the 1970s, Gronk's work has been represented in numerous private and museum collections across the country and he has had many solo exhibitions.

Raul Guerrero

Raul Guerrero was born in 1945 in Brawley, California, a small town located near Mexicali, Mexico. He studied at the Chouinard Art School in Los Angeles, California, where he obtained a Bachelor of Fine Arts in 1969. Guerrero has been influenced by the works of French Dada artist Marcel Duchamp. Through Duchamp's works, Guerrero felt a need to become more conscious of his art and approach the work deductively rather than expressionistically. His works include *Molino Rojo* and *Club Coco Tijuana*. Guerrero's work has been exhibited in various cities across the nation, including Santa Fe, Los Angeles, San Diego, San Francisco, and New York City.

Wayne Alaniz Healy

Wayne Alaniz Healy was raised in East Los Angeles, where he continues to live and paint. Healy is a founding member of one of the first 1970s muralist groups, the East Los Streetscapers. He and fellow founder, David Botello, painted their first mural together—dinosaurs—in third-grade art class. The artist and the Streetscapers have recently moved into such multimedia work as sculpture and tile-making.

Adan Hernández

Adan Hernández's work merges neo-Expressionism with Chicano-noir. The aesthetics in his art evoke emotions of alienation, uncertainty, desperation, and loss, which dominate the Chicano experience. In describing his work, Hernández says, "the high drama and highly charged content in my work reflects the day-to-day epic struggle of life in the barrio. Here, the challenge to overcome overwhelming adversity, which we celebrate in films, is a common occurrence. I feel my work is about the priorities in my life and the experiences that have shaped it. These moments seek eternal life in my art."

In 1991, Hernández's work caught the attention of film director Taylor Hackford (*La Bamba, Devil's Advocate*), who signed him up to create more than thirty original paintings, drawings, and a mural, and to star in a cameo role for the 1993 epic barrio-cult-classic, "*Blood In…Blood Out.*" Hernández, who has been actively painting the past two decades, has had his work exhibited in museums in the United States and Mexico.

Ester Hernández

Ester Hernández, an artist of Mexican and Yaqui descent, was born and raised in Dinuba, a small town on the western slope of the Sierra Nevada mountains. The child of farm workers, Hernández grew up in an atmosphere of natural beauty, mixed cultural traditions, and social activism. The Hernández family was actively involved in the struggle for the rights of farm workers since the 1930s. Moving to the Bay Area in the early 1970s to study Chicano Studies at Laney College and then visual arts at the University of California Berkeley, Hernández graduated with honors and a degree in art. During this period, she met and became involved with Las Mujeres Muralistas, San Francisco's first all-Latina mural collective.

Though Hernández works as a muralist and painter, she primarily considers herself a printmaker. Hernández has taught art in elementary school, college, and senior citizen centers, and currently works with disabled adults at San Francisco's Creativity Explored. She is the recipient of several California Arts Council grants, and her work has been featured in numerous exhibits in the United States, Mexico, and England, including "CARA—Chicano Art: Resistance and Affirmation 1965-1985." She currently resides in San Francisco.

Leo Limón

Leo Limón was born and still resides in East Los Angeles. Called the "Alley River cat artist" by former Los Angeles Mayor Richard Riordan, he is known for the cat faces he paints on the cement walls channeling the Los Angeles River. Limón's work on paper deals mostly with the indigenous ideals of "*corazón*" and uses many Aztec symbols.

Limón considers himself a cultural worker and an arts ambassador for East Los Angeles and the Chicano community. While he was in high school, Limón was influenced by and involved with Los Four, especially by Carlos Almaraz in the group. During his time with Self-Help Graphics, a community-based visual arts center, Limón helped to develop the annual celebration of *Día de Los Muertos* and the Atelier Printmaking Program. In addition, Limón helped to establish the Aztlán Cultural Arts Foundation, Inc., to pursue his commitment to youth in his community. He has also worked with the MeChicano Art Center and the Centro de Arte Público.

Gilbert "Magu" Lujan

Gilbert Lujan was born near French Camp, California, a migrant farm workers' village, and moved to East Los Angeles around the beginning of World War II. He first began painting murals in East Los Angeles in the early 1970s. In 1973, he joined with Frank Romero, Carlos Almaraz, and Roberto de la Rocha to found Los Four. Los Four collaborated on numerous murals and on other public art installations throughout California during the next ten years, and had a major influence in defining Chicano art in California. Lujan has exhibited his paintings and sculptures in numerous solo and group shows in the United States and abroad.

César Martínez

César Martínez, born in Laredo, Texas, was a major figure in the Chicano art movement in the late 1970s and 1980s. He is based in San Antonio, where he makes portraits which have become icons of Texas art history. Martínez's work has been included in the landmark exhibits "La Frontera/The Border: Art About the Mexican/U.S. Border Experience"; "CARA—Chicano Art: Resistance and Affirmation 1965-1985," and "Hispanic Art in the United States." He has also shown at the Mexican Fine Arts Center Museum, Chicago; Museo de Arte Moderno, Mexico City; the San Antonio Museum of Art, San Antonio; and the Contemporary Arts Museum, Houston.

This painter and printmaker is primarily known for his *Bato* series of portraits of *pachucos* and *rucas*. He also paints abstracted landscapes that incorporate Aztec imagery and history, and creates constructions made of found wood.

Frank Romero

Los Angeles native Frank Romero studied art at Otis College of Art and Design and California State College (now California State University) at Los Angeles. Romero was one of the founders of Los Four, whose collaborations brought Chicano street art to the attention of the mainstream art community of Los Angeles. The University of California, Irvine, presented an exhibition of the group in 1974, which subsequently was shown at the Los Angeles County Museum of Art and the Oakland Museum.

Romero worked as a designer for Charles Eames and A&M Records, and was the design director of the community redevelopment agency when he designed the first section of the *Broadway Sidewalk Project*. Set between 3rd and 8th streets on one of the city's densest pedestrian traffic areas, the *Broadway Sidewalk Project* is a series of three murals that incorporate cultural images from many ethnic groups that shop on Broadway. In 1981, he curated the highly regarded exhibition "The Murals of Atzlán" at the Craft and Folk Art Museum. Although he is known as one of the city's foremost muralists, Romero is now primarily a studio artist. His work has been exhibited in many solo and group shows including the national exhibitions, "Hispanic Art in the United States" and "CARA—Chicano Art: Resistance and Affirmation 1965-1985."

Alex Rubio

San Antonio artist Alex Rubio, nicknamed "El Diablito," began his career as a young muralist in a housing project. He developed his talent by serving his community as a youth instructor and creating murals on cathedral walls. His artwork focuses on narrative drawings and paintings with mixed media, based on images rooted in his Latin American culture.

As part of the Inmate Creative Arts Program (ICAP), Rubio is artist-in-residence at the Bexar County Detention Ministry in San Antonio, where he teaches inmates about art. He has also curated exhibits of their work and has included some of the inmates' art with exhibits of his own work. Rubio has exhibited throughout the Southwestern United States, as well as in New York and Puerto Rico.

Marta Sánchez

Marta Sánchez was born in San Antonio, Texas. In addition to her works on paper and metal, Sánchez has painted interior murals and floor paintings. She also founded "*Cascarone por la vida*" (Shell for Life), an annual fundraiser benefiting children with AIDS and the homeless in Philadelphia. Sánchez received a Master of Fine Arts degree from Tyler School of Art in Philadelphia and a Bachelor of Fine Arts degree from University of Texas in Austin, both in painting.

Sánchez credits her experience growing up as a Chicana in Texas and with Mexican *retablos*—prayer paintings on metal depicting hope—as the source for her artistic perspective. Her works, including *Train Series* in memory of her father and her old neighborhood, have been featured in exhibitions around the United States and Mexico. She lives in Philadelphia.

Eloy Torrez

Eloy Torrez is a painter, artist, muralist, and art instructor. Born in Albuquerque, New Mexico, he lives and works in Los Angeles. He has a Bachelor of Fine Arts degree from Otis College of Art and Design.

Torrez has executed murals in the Southern California area, including the well-known *The Pope of Broadway*, or Anthony Quinn mural, at the Victor Clothing Co. buildings in downtown Los Angeles at 240 S. Broadway. He has also painted murals in St. Denis, France, when he was working there as an artist in residence. His oil paintings and works on paper have been exhibited in galleries and museums in the United States, Mexico, and Europe. He teaches drawing to youths at risk at the Covenant House in Hollywood, California, as well as art and mural painting to children, youth, and adults. Torrez also composes pop music, sings, and plays guitar.

Jesse Treviño

Jesse Treviño has earned an international reputation by painting the people, landmarks, and culture of west side San Antonio, Texas, where he grew up with his eleven brothers and sisters. Although he was born in Monterrey, Mexico, San Antonians embrace him as their native son. Treviño is widely recognized for his larger-than-life work, colorful realist paintings, and tile murals depicting Hispanic culture.

John Valadez

Los Angeles-born John Valadez earned his Bachelor of Fine Arts degree in 1976 from California State University, Long Beach, and was one of the founding members of the Public Arts Center in Highland Park, organized to provide studio space and access to cooperative mural projects. During the middle and late 1970s, Valadez often worked on mural projects with young people; none of those murals exist today. He has created murals for the General Services Administration in El Paso, Texas, and the federal courthouse in Santa Ana, California.

In 1980, Valadez was included in a group exhibition, "Espina," at LACE Gallery, Los Angeles, where his work was seen by the owner of the Victor Clothing Co. Valadez was invited to submit a proposal for portraits to hang in the store; a year and a half later, he completed work on *The Broadway Mural* at 240 S. Broadway, which remains one of the most extraordinary achievements to grow out of the mural movement. Valdez has had several solo exhibitions in Los Angeles galleries, as well as in San Francisco and New York.

Patssi Valdez

Patssi Valdez began her artistic career in the 1970s as a Garfield High School student in East Los Angeles. She was the only female among the seminal, four-member Chicano art group Asco. Asco expanded the definition of Chicano art beyond murals and posters by experimenting with a range of art forms, including street performance, photographic montage, pageantry, and conceptual art. She has also done set design work on films.

In January 2001, "Patssi Valdez: A Precarious Comfort" opened at The Mexican Museum in San Francisco. In March, Valdez was one of only three Los Angeles artists awarded a $25,000 Durfee Artist Fellowship based on past artistic achievement and future promise.

Vincent Valdez

Vincent Valdez was born and raised in San Antonio, Texas, and is the youngest artist represented in the Chicano exhibition. His first artistic influences came from the canvases of his late great-grandfather, an artist from Spain. Valdez began drawing at the age of three; as early as kindergarten, he realized his artistic abilities differed from others. While participating in a mural project at San Antonio's Esperanza Peace and Justice Center when he was only ten years old, Valdez decided art would be his career. He worked with his mentor, artist/muralist Alex Rubio, on murals around the Alamo City, eventually painting on his own.

Upon graduating from Burbank High School, Valdez received a full scholarship to the International Fine Arts College in Miami, Florida. After one year, he accepted a full scholarship and transferred to the Rhode Island School of Design in Providence, Rhode Island, where he completed his Bachelor of Fine Arts degree in illustration. Valdez exhibits and works on commissioned pieces and teaches art to middle school students in San Antonio.

George Yepes

Called "the City's Preeminent Bad Ass Muralist" (*L.A. New Times,* June 2000), George Yepes was also named a "treasure of Los Angles" in 1997 by Mayor Richard Riordan. Born in Tijuana, raised in East Los Angeles, and formed by a street life of poverty and gang violence, Yepes calls on classical master works from Velásquez to Titian for inspiration. This self-taught artist has a distinctly refined renaissance bent to his work, although religious iconography and erotica are also prevalent. His paintings and murals combine the bravado of Chicano street sense with classical standards. His album cover for Los Lobos, titled *La Pistola y el Corazon,* has won numerous awards and is in many museum collections. The twenty-eight public murals he has done in Los Angeles are recognized landmarks, as are the twenty-one murals painted by students in his Academia de Arte Yepes.

List of Plates

Carlos Almaraz. *California Natives*. 1988. Oil on canvas, 84 x 60". Collection Cheech and Patti Marin

Carlos Almaraz. *Creatures of the Earth*. 1984. Oil on canvas, 35 x 43". Collection Cheech and Patti Marin

Carlos Almaraz. *Early Hawaiians* (triptych). 1983. Oil on canvas, 163 x 72" overall. Collection Los Angeles County Museum of Art. Gift of William H. Bigelow, III. M.91.288 a-c. © 2002 The Carlos Almaraz Estate

Carlos Almaraz. *Flipover*. 1983. Oil on canvas, 72 x 36". Collection Mrs. Liz Michaels Hearne and John Hearne

Carlos Almaraz. *Pyramids* (triptych). 1984. Oil on canvas, 144 x 96" overall. Collection Cheech and Patti Marin

Carlos Almaraz. *Southwest Song*. 1988. Serigraph, 48 x 34½". Collection Cheech and Patti Marin

Carlos Almaraz. *Sunset Crash*. 1982. Oil on canvas, 43 x 35". Collection Cheech and Patti Marin

Carlos Almaraz. *The Two Chairs*. 1986. Oil on canvas, 66 x 79½". Collection Cheech and Patti Marin

Carlos Almaraz. *West Coast Crash*. 1982. Oil on canvas, 54 x 18". Collection Elsa Flores Almaraz

Chaz Bojórquez. *Chino Latino*. 2000. Acrylic on canvas, 72 x 60". Collection Cheech and Patti Marin

Chaz Bojórquez. *Words That Cut*. 1991. Acrylic on canvas, 92 x 65". Collection Nicolas Cage

David Botello. *Alone and Together Under the Freeway*. 1992. Acrylic on canvas, 34 x 25". Collection Cheech and Patti Marin

David Botello. *Wedding Photos-Hollenbeck Park*. 1990. Oil on canvas, 47½ x 35¼". Collection Cheech and Patti Marin

Mel Casas. *Humanscape 62 (Brownies of the Southwest)*. 1970. Oil on canvas, 97 x 73". Collection the artist

Mel Casas. *Humanscape 63 (Show of Hands)*. 1970. Oil on canvas, 97 x 73". Collection the artist

Mel Casas. *Humanscape 68 (Kitchen Spanish)*. 1973. Oil on canvas, 97 x 73". Collection the artist

Gaspar Enríquez. *Tirando Rollo (I Love You)* (triptych). 1999. Acrylic on paper, 81 x 58" overall. Collection Cheech and Patti Marin

Diane Gamboa. *Green Hair*. 1989. Oil on paper, 18 x 25". Collection Cheech and Patti Marin

Diane Gamboa. *She Never Says Hello*. 1986. Mixed media on paper, 24 x 36". Collection Cheech and Patti Marin

Diane Gamboa. *Tame a Wild Beast*. 1991. Oil on canvas, 54 x 54". Collection the artist

Diane Gamboa. *Time in Question*. 1991. Oil on canvas, 54 x 54". Collection the artist

Margaret García. *Eziquiel's Party*. 2000. Oil on canvas, 54¼ x 44¾". Collection Cheech and Patti Marin

Margaret García. *Janine at 39, Mother of Twins*. 2000. Oil on canvas, 47½ x 35½". Collection Cheech and Patti Marin

Margaret García. *Un Nuevo Mestizaje Series* (The New Mix). (16 works). 1987–2001. Oil on canvas, oil on wood, 96 x 96" overall. Collection the artist

Rupert García. *Homenaje A Tania y The Soviet Defeat* (Homage to Tania and the Soviet Defeat) (diptych). 1987. Oil on linen, 101 x 69" overall. Collection the artist

Rupert García. *La Virgen de Guadalupe & Other Baggage*. 1996. Pastel on three sheets of museum board, 31½ x 40" each. Collection the artist. Courtesy the artist and the Rena Bransten Gallery, San Francisco, and Galerie Claude Samuel, Paris

Carmen Lomas Garza. *Earache Treatment Closeup*. 2001. Oil and alkyd on canvas, 14 x 18". Collection the artist

Carmen Lomas Garza. *Heaven and Hell II*. 1991. Oil and alkyd on canvas, 48 x 36". Collection the artist © 1991 Carmen Lomas Garza

Carmen Lomas Garza. *Quinceañera* (The Fifteenth Birthday). 2001. Oil and alkyd on linen on wood, 48 x 36". Collection the artist

Carmen Lomas Garza. *Una Tarde/One Summer Afternoon*. 1993. Alkyd on canvas, 32 x 24". Collection the artist © 1993 Carmen Lomas Garza

Gronk. *Getting the Fuck Out of the Way*. 1987. Oil on canvas, 48 x 48". Collection Cheech and Patti Marin

Gronk. *Hot Lips*. 1989. Acrylic on canvas, 67 x 70". Collection William Link and Margery Nelson

Gronk. *Josephine Bonaparte Protecting the Rear Guard*. 1987. Acrylic on canvas, 60 x 72". Collection Joanna Giallelis

Gronk. *La Tormenta Returns* (triptych). 1998. Acrylic and oil on wood, 144 x 96" overall. Collection Cheech and Patti Marin

Gronk. *Pérdida (ACCENT ON THE e)*. (Lost). 2000. Mixed media on handmade paper mounted on wood, 118 x 60". Collection Cheech and Patti Marin

Raul Guerrero. *Club Coco Tijuana*. 1990. Gouache and chalk pastel on Arches paper, 22¼ x 14¼". Collection Cheech and Patti Marin

Raul Guerrero. *Molino Rojo* (Moulin Rouge). 1989. Arches paper, pastel, and gouache, 15 x 22". Collection Cheech and Patti Marin

Wayne Alaniz Healy. *Beautiful Downtown Boyle Heights*. 1993. Acrylic on canvas, 94 x 69¾". Collection Cheech and Patti Marin

Wayne Alaniz Healy. *Pre-Game Warmup*. 2001. Acrylic on canvas, 120 x 96". Collection Cheech and Patti Marin

Wayne Alaniz Healy. *Una Tarde en Meoqui* (An Afternoon in Meoqui). 1991. Acrylic on canvas, 53½ x 53¾". Collection Cheech and Patti Marin

Adan Hernández. *Drive-by Asesino* (diptych). 1992. Oil on canvas, 55 x 60¼" overall. Collection Cheech and Patti Marin

Adan Hernández. *La Bomba* (diptych). 1992. Oil on canvas, 57 x 59" overall. Collection Cheech and Patti Marin

Adan Hernández. *La Estrella que Cae* (The Falling Star). 1991. Oil on canvas, 48 x 58". Collection Cheech and Patti Marin

Adan Hernández. *Sin Titulo II* (Untitled). 1988. Oil on canvas, 60 x 46". Collection Lisa Ortiz

Ester Hernández. *Astrid Hadad in San Francisco*. 1994. Pastel on paper, 30 x 44". Collection Cheech and Patti Marin

Leo Limón. *Ay! Dream of Chico's Corazon* (Dream of Chico's Heart). 1992. Acrylic on canvas, 10½ x 13½". Collection Cheech and Patti Marin

Leo Limón. *Cup of Tochtli*. 1997. Pastel on paper, 20½ x 19½". Collection Cheech and Patti Marin

Leo Limón. *Frida and Palomas*. 2001. Acrylic on canvas, 24 x 36". Collection Cheech and Patti Marin

Leo Limón. *Los Muertos*. 1998. Acrylic on canvas, 56 x 40". Collection Cheech and Patti Marin

Leo Limón. *Mas Juegos* (More Games). 2000. Acrylic on canvas, 48 x 69¾". Collection Cheech and Patti Marin

Leo Limón. *Un Poquito Sol*. 1991. Acrylic on canvas, 47¼ x 59". Collection Cheech and Patti Marin

Leo Limón. *Wild Ride*. 1996. Pastel on paper, 25¼ x 19". Collection Cheech and Patti Marin

Gilbert Lujan. *Blue Dog*. 1990. Pastel on paper, 44 x 30". Collection Cheech and Patti Marin

Gilbert Lujan. *Boy and Dog*. 1990. Pastel on paper, 44 x 30". Collection Cheech and Patti Marin

César Martínez. *Bato con Cruz* (Dude with Cross). 1993. Watercolor on paper, 17¾ x 21¾". Collection Cheech and Patti Marin

César Martínez. *Bato con Sunglasses*. 2000. Oil on canvas, 44 x 54". Collection Cheech and Patti Marin

César Martínez. *Camisa de Cuadros* (Shirt with Squares). 1990. Watercolor on paper, 14 x 18". Collection Cheech and Patti Marin

César Martínez. *El Guero* (The Light-Skinned One). 1987. Oil on canvas, 44 x 54". Collection Cheech and Patti Marin

César Martínez. *Hombre que le Gustan las Mujeres* (The Man Who Loves Women). 2000. Oil on canvas, 44 x 54". Collection Cheech and Patti Marin

César Martínez. *Sylvia With Chago's Letter Jacket*. 2000. Oil on canvas, 44 x 54". Collection Cheech and Patti Marin

Frank Romero. *The Arrest of the Paleteros* (diptych). 1996. Oil on canvas, 144 x 96" overall. Collection Cheech and Patti Marin

Frank Romero. *Back Seat Dodge, Homage to Keinholtz*. 1991. Oil on canvas, 47½ x 35½". Collection Cheech and Patti Marin

Frank Romero. *Cruising #1*. 1988. Monoprint, 29½ x 22". Collection Cheech and Patti Marin

Frank Romero. *Downtown Streetscape*. 2000. Oil on canvas, 52 x 40". Collection Cheech and Patti Marin

Frank Romero. *¡Méjico, Mexico!* (4 panels). 1984. Mixed media, 288 x 120" overall. Collection Cheech and Patti Marin

Frank Romero. *Johanna*. 1991. Pastel on paper, 40 x 22". Collection Cheech and Patti Marin

Frank Romero. *La Llorona* (The Weeping Women). 1985. Oil on canvas, 50 x 72". Collection Cheech and Patti Marin

Frank Romero. *Pink Landscape*. 1984. Oil on canvas, 60¼ x 36″. Collection Cheech and Patti Marin

Alex Rubio. *La Lechuza* (The Owl Woman). 2001. Oil on wood panel, 48 x 84". Collection Cheech and Patti Marin

Marta Sánchez. *La Danza* (The Dance). 1994. Oil enamel on metal, 35½ x 59½". Collection Cheech and Patti Marin

Eloy Torrez. *Diane Gamboa*. 2000. Oil on canvas, 18¼ x 33". Collection Cheech and Patti Marin

Eloy Torrez. *Herbert Siguenza*. 2000. Oil on canvas, 15 x 19". Collection Cheech and Patti Marin

Eloy Torrez. *The Red Floor*. 1990. Acrylic on paper, 35 x 55". Collection Cheech and Patti Marin

Jesse Treviño. *Guadalupe y Calaveras*. 1976. Acrylic on canvas, 66 x 48". Collection Terry Vasquez

Jesse Treviño. *Los Piscadores*. 1985. Acrylic on canvas, 82 x 48". Collection Judge Juan F. Vasquez

John Valadez. *Beto's Vacation (Water, Land, Fire)* (triptych). 1985. Pastel on paper, 50 x 68", 50 x 72", 50 x 68". Collection Dennis Hopper

John Valadez. *Car Show*. 2001. Oil on canvas, 96¼ x 76". Collection Dennis Hopper

John Valadez. *Getting Them Out of the Car*. 1984. Pastel on paper, 100 x 37½". Collection Cheech and Patti Marin

John Valadez. *Pool Party*. 1986. Oil on canvas, 107 x 69". Collection Cheech and Patti Marin

John Valadez. *Revelations*. 1991. Pastel on paper, 50½ x 61". Collection Cheech and Patti Marin

John Valadez. *Tony and Edie*. 1986. Pastel on paper, 50 x 38". Collection Robert Berman

Patssi Valdez. *Autumn*. 2000. Acrylic on canvas, 52 x 66". Collection Cheech and Patti Marin

Patssi Valdez. *Broken Dreams*. 1988. Acrylic on canvas, 36¼ x 36½". Collection Cheech and Patti Marin

Patssi Valdez. *The Dream*. 2000. Acrylic on canvas, 96 x 72". Collection the artist

Patssi Valdez. *Happy Birthday*. 2000. Acrylic on canvas, 72 x 48". Collection Cheech and Patti Marin

Patssi Valdez. *Little Girl With Yellow Dress*. 1995. Acrylic on canvas, 36 x 36". Collection Cheech and Patti Marin

Patssi Valdez. *Rainy Night*. 2000. Acrylic on canvas, 53 x 66". Collection Cheech and Patti Marin

Patssi Valdez. *Room on the Verge*. 1993. Acrylic on canvas, 72 x 48". Collection Cheech and Patti Marin

Patssi Valdez. *Saturday*. 1997. Acrylic on canvas, 24 x 36". Collection Cheech and Patti Marin

Vincent Valdez. *Kill the Pachuco Bastard!*. 2001. Oil on canvas, 72 x 48". Collection Cheech and Patti Marin

George Yepes. *Axis Bold as Love*. 2001. Acrylic on canvas, 60 x 96". Collection Cheech and Patti Marin

George Yepes. *La Magdalena*. 2000. Oil on canvas, 41 x 80". Collection Cheech and Patti Marin

George Yepes. *La Pistola y el Corazon* (The Pistol and the Heart). 1989. Serigraph, 34 x 42". Collection Cheech and Patti Marin

George Yepes. *La Pistola y el Corazon* (The Pistol and the Heart). 2000. Oil on canvas, 60 x 81½". Collection Cheech and Patti Marin

CREDITS

The author, publisher, and exhibition organizer fully acknowledge the photographers, museums, and individuals for supplying the necessary materials and permission to reproduce their work. Unless otherwise noted below, all works were photographed by Peggy Tenison or John White.

M. Lee Fatherree: © 1993 Carmen Lomas Garza, *Una Tarde* and © 1991 Carmen Lomas Garza, *Heaven and Hell II*

Los Angeles County Museum of Art: Carlos Almaraz, *Early Hawaiians*

David Shindo: Gaspar Enríquez, *Tirando Rollo*

Tom Wilson: Mel Casas, *Humanscape 62, Humanscape 63,* and *Humanscape 68*

ACKNOWLEDGMENTS

There are a number of people and institutions I'd like to thank, but it seems fitting that I begin with Stacy King, President and CEO of Clear Channel Entertainment, Inc., for her faith in this project and for being so instrumental and imaginative in developing the exhibition "Chicano Visions." Also at Clear Channel, my thanks to Anne Powers, Mark Greenberg, Dennis Bartz, Cathryn LeVrier, Michele Stevens, and Delfina Sanchez. A special nod of appreciation goes to Peter Radetsky, working in conjunction with Clear Channel, for organizing the Chicano experience into a coherent exhibition.

Target Stores have been great in helping us to get this exhibition off the ground and for being generous in their support. My thanks also go to the Hewlett-Packard Company for helping to fund this exhibition.

Over the years, I have had the pleasure to work with a number of art dealers who opened the world of Chicano art to me, among them: Robert Berman, Daniel Saxon, Sofia Perez, Julie Rico, Craig Krull. Gabriella Trench stands out for having been my eyes, my ears, even my legs in assembling part of my collection.

To the lenders of the exhibition and this book—institutions, patrons, and artists—*muchas gracias.*

Director George Neubert at the San Antonio Museum of Art has been a longtime supporter of Chicano art, and the museum deserves many hosannahs for having been the first to mount this great survey of Chicano artists. At the Museo Americano, I want to thank Henry Muñoz, the director and founding chairman of the Alameda, and his staff.

How could I not thank the distinguished publishing house, Bulfinch Press? Carol Judy Leslie was the person who first championed this project before it passed into the capable and energetic hands of publisher Jill Cohen. Also at Bulfinch, Karyn Gerhard was key in moving the book along its way.

Behind the scenes, and working with me to make this book fantastic, is my editor, Ruth Peltason, of Bespoke Books. Ruth's tireless efforts have guided this book through the course of its long journey. Without her, this book truly would not have been possible. And to the book designer, Ana Rogers, thank you for understanding Chicano art so well.

To my wife, Patti, my love always for her great and different eye.

And thanks, above all, to the artists for creating the work that we celebrate in this book.

Con amor y besos,
Cheech Marin